T0301958

An Analysis of

Virginia Woolf's

A Room of One's Own

Fiona Robinson
with
Tim Smith-Laing

Published by Macat International Ltd
24:13 Coda Centre, 189 Munster Road, London SW6 6AW.

Distributed exclusively by Routledge
2 Park Square, Milton Park, Abingdon, Oxon OX14 4RN
711 Third Avenue, New York, NY 10017, USA

Routledge is an imprint of the Taylor & Francis Group, an informa business

www.macat.com
info@macat.com

Cataloguing in Publication Data
A catalogue record for this book is available from the British Library.
Library of Congress Cataloguing-in-Publication Data is available upon request.
Cover illustration: Capucine Deslouis

ISBN 978-1-912302-91-8 (hardback)
ISBN 978-1-912127-82-5 (paperback)
ISBN 978-1-912281-79-4 (e-book)

Notice
The information in this book is designed to orientate readers of the work under analysis,
to elucidate and contextualise its key ideas and themes, and to aid in the development
of critical thinking skills. It is not meant to be used, nor should it be used, as a
substitute for original thinking or in place of original writing or research. References and
notes are provided for informational purposes and their presence does not constitute
endorsement of the information or opinions therein. This book is presented solely for
educational purposes. It is sold on the understanding that the publisher is not engaged
to provide any scholarly advice. The publisher has made every effort to ensure that
this book is accurate and up-to-date, but makes no warranties or representations with
regard to the completeness or reliability of the information it contains. The information
and the opinions provided herein are not guaranteed or warranted to produce particular
results and may not be suitable for students of every ability. The publisher shall not be
liable for any loss, damage or disruption arising from any errors or omissions, or from
the use of this book, including, but not limited to, special, incidental, consequential or
other damages caused, or alleged to have been caused, directly or indirectly, by the
information contained within.

CONTENTS

THE MACAT LIBRARY

The Macat Library is a series of unique academic explorations of seminal works in the humanities and social sciences – books and papers that have had a significant and widely recognised impact on their disciplines. It has been created to serve as much more than just a summary of what lies between the covers of a great book. It illuminates and explores the influences on, ideas of, and impact of that book. Our goal is to offer a learning resource that encourages critical thinking and fosters a better, deeper understanding of important ideas.

Each publication is divided into three Sections: Influences, Ideas, and Impact. Each Section has four Modules. These explore every important facet of the work, and the responses to it.

This Section-Module structure makes a Macat Library book easy to use, but it has another important feature. Because each Macat book is written to the same format, it is possible (and encouraged!) to cross-reference multiple Macat books along the same lines of inquiry or research. This allows the reader to open up interesting interdisciplinary pathways.

To further aid your reading, lists of glossary terms and people mentioned are included at the end of this book (these are indicated by an asterisk [*] throughout) – as well as a list of works cited.

Macat has worked with the University of Cambridge to identify the elements of critical thinking and understand the ways in which six different skills combine to enable effective thinking.
Three allow us to fully understand a problem; three more give us the tools to solve it. Together, these six skills make up the **PACIER** model of critical thinking. They are:

ANALYSIS – understanding how an argument is built
EVALUATION – exploring the strengths and weaknesses of an argument
INTERPRETATION – understanding issues of meaning

CREATIVE THINKING – coming up with new ideas and fresh connections
PROBLEM-SOLVING – producing strong solutions
REASONING – creating strong arguments

To find out more, visit **WWW.MACAT.COM.**

CRITICAL THINKING AND *A ROOM OF ONE'S OWN*

Primary critical thinking skill: CREATIVE THINKING
Secondary critical thinking skill: REASONING

A Room of One's Own is a very clear example of how creative thinkers connect and present things in novel ways.

Based on the text of a talk given by Virginia Woolf at an all-female Cambridge college, Room considers the subject of 'women and fiction.' Woolf's approach is to ask why, in the early 20th century, literary history presented so few examples of canonically 'great' women writers. The common prejudices of the time suggested this was caused by (and proof of) women's creative and intellectual inferiority to men. Woolf argued instead that it was to do with a very simple fact: across the centuries, male-dominated society had systematically prevented women from having the educational opportunities, private spaces and economic independence to produce great art. At a time when 'art' was commonly considered to be a province of the mind that had no relation to economic circumstances, this was a novel proposal. More novel, though, was Woolf's manner of arguing and proving her contentions: through a fictional account of the limits placed on even the most privileged women in everyday existence. An impressive early example of cultural materialism, *A Room of One's Own* is an exemplary encapsulation of creative thinking.

ABOUT THE AUTHOR OF THE ORIGINAL WORK

Virginia Woolf was one of the Bloomsbury Group of radical intellectuals, writers, artists, and innovators, who were famous in London in the 1920s and 1930s. Born in 1882 into an upper-class intellectual family, she was educated at home and published her first novel in 1915, writing seven in total before her death in 1941.

Works such as *Mrs Dalloway* and *To The Lighthouse* ensured Woolf's reputation as one of the greatest novelists of the twentieth century. Although she came from a privileged background, she nevertheless experienced and understood the everyday oppression of women. Her theories on feminism inspired her 1929 essay *A Room of One's Own*. It remains a seminal text in feminist writing, and is still relevant today in many areas of social injustice.

ABOUT THE AUTHORS OF THE ANALYSIS

Dr Tim Smith-Laing took his DPhil at Merton College, Oxford, and has held positions at Jesus College, Oxford, and Sciences Po in Paris.

Dr Fiona Robinson holds a PhD in early twentieth-century English literature from Yale University.

ABOUT MACAT

GREAT WORKS FOR CRITICAL THINKING

Macat is focused on making the ideas of the world's great thinkers accessible and comprehensible to everybody, everywhere, in ways that promote the development of enhanced critical thinking skills.

It works with leading academics from the world's top universities to produce new analyses that focus on the ideas and the impact of the most influential works ever written across a wide variety of academic disciplines. Each of the works that sit at the heart of its growing library is an enduring example of great thinking. But by setting them in context – and looking at the influences that shaped their authors, as well as the responses they provoked – Macat encourages readers to look at these classics and game-changers with fresh eyes. Readers learn to think, engage and challenge their ideas, rather than simply accepting them.

'Macat offers an amazing first-of-its-kind tool for interdisciplinary learning and research. Its focus on works that transformed their disciplines and its rigorous approach, drawing on the world's leading experts and educational institutions, opens up a world-class education to anyone.'

Andreas Schleicher
Director for Education and Skills, Organisation for Economic
Co-operation and Development

'Macat is taking on some of the major challenges in university education ... They have drawn together a strong team of active academics who are producing teaching materials that are novel in the breadth of their approach.'

Prof Lord Broers,
former Vice-Chancellor of the University of Cambridge

'The Macat vision is exceptionally exciting. It focuses upon new modes of learning which analyse and explain seminal texts which have profoundly influenced world thinking and so social and economic development. It promotes the kind of critical thinking which is essential for any society and economy. This is the learning of the future.'

Rt Hon Charles Clarke, former UK Secretary of State for Education

'The Macat analyses provide immediate access to the critical conversation surrounding the books that have shaped their respective discipline, which will make them an invaluable resource to all of those, students and teachers, working in the field.'

Professor William Tronzo, University of California at San Diego

WAYS IN TO THE TEXT

KEY POINTS

- The British novelist and critic Virginia Woolf was born in 1882 and grew up in London. Her experiences as a female writer helped form her theories on literature and feminism*—an intellectual and political movement seeking equality between the sexes.

- *A Room of One's Own*, published in 1929, was innovative in its focus on the problems faced by women in day-to-day life and their effects on the mind, rather than on legal obstacles faced by women.

- *A Room of One's Own* is a vital document in the history of feminism. It still attracts a broad audience in and beyond academia, and remains influential in feminist literary criticism.

Who Was Virginia Woolf?

Virginia Woolf, the author of *A Room of One's Own*, was born in 1882 and grew up in the London district of Kensington in an upper-class intellectual household. She and her sister Vanessa did not attend school or university, like their brothers, but were educated at home instead; this was typical of attitudes at the time. In spite of this limitation, Woolf gained a better education than most women of the age. Her father—a journalist, historian, and biographer—

had an extensive library and she had full access to it. As a result, Woolf gained a wide knowledge of literature, which was vital to her intellectual development.

Through her brothers, Thoby* and Adrian,* Woolf became friends in her youth with a group of intellectuals, artists, and writers later known as the Bloomsbury Group.* They met frequently at the house Woolf shared with her siblings in London's Bloomsbury Square. Several of the Bloomsbury Group, including Woolf, were important innovators in the fields of art, literature, and economics. They were also fiercely independent thinkers who went against many of the standard codes of the age.

Woolf published her first novel in 1915, and went on to publish seven more before her death in 1941. Her final novel, finished shortly before her suicide, was published posthumously. Woolf's writing was successful in her own time, and she was regarded as one of the brightest lights in modern literature. Since her death, her reputation has continued to grow. She is considered one of the greatest novelists of the twentieth century.

What Does *A Room of One's Own* Say?

Despite her success and privileges, Woolf was still a woman born into a man's age. Her personal experiences of the limits placed on women by British society in the early twentieth century directly inform her 1929 essay *A Room of One's Own*. The essay asks two central questions: why have there been so few great women writers in history? And what does one need in order to write?

Woolf answers the second question first. Part of her answer gives the essay its title: to write, one must have a private room. The second part is that one must have money. Woolf settles on the figure of £500 a year—in 1929 a steady and comfortable income. These are necessary for writing, Woolf states, because writing depends on everyday life. In order to write, you must have privacy, and you must be free of worries

about money. Only with privacy and security can a person create art.

This idea is a direct response to the way women lived in the early twentieth century. Though their legal rights were being increased, women still had fewer rights than men. There were restrictions on women's ability to own property and to be educated. There were also clear social expectations that placed limits on women. Marriage was regarded as a primary social goal and, once married, women were expected not to work. They were also expected to devote their lives to their husbands and children. As a result, married women generally had no income of their own, and no real privacy. Hence Woolf's demand for two simple things that many today would take for granted.

The first question—why have there been so few great women writers?— is more complicated. In the early twentieth century, women were routinely thought to be less intelligent than men, and the lack of famous women writers and artists in history was often presented as evidence of this. Woolf, however, assumes that women are just as intelligent as men and looks for other causes. If women have not written great books, she suggests, it is because something has prevented them.

What, though? In Woolf's analysis, society throughout history has created conditions in which no woman could write. Women have not had privacy, money, or education. Woolf suggests that even the most exceptionally talented woman could not write in such a society. It is not intellectual inferiority that has made it impossible for women to write literature—it is the conditions of everyday life.

Woolf also presents a third reason for the lack of great present-day female writers: the absence of famous female writers in history. She argues that female writers need a tradition of older female writers in order to produce great work. She encourages women in her own time to write, no matter what the subject, in order to create such a tradition. Only then, she argues, will future women be able to write great books.

Why Does *A Room of One's Own* Matter?

It is hard to overstate the importance of *A Room of One's Own* in the history of feminism. When Woolf wrote the essay in 1929, women in Britain were at a turning point. For the first time, they had full voting rights, and were breaking other legal barriers to equality. But much of the early feminist movement was focused on winning legal rights alone. Woolf's essay was a crucial reminder that inequality had deeper causes than unjust laws. In her view, women's lower status in society affected every area of their lives, and came from the smallest everyday conditions. *A Room* shifted the emphasis of feminism from legal battles to altering everyday life too.

Woolf clarified this focus by addressing a central question of literary criticism: what does it take to produce great art? In the early twentieth century, a majority of academics and critics believed that great art was a product of "genius." Such genius was assumed to be greater than any social barriers. It would express itself regardless of poverty, lack of education, or want of time and privacy. The absence of great women writers and artists in history was therefore seen as evidence that women could not be geniuses. This in turn justified social structures that treated them as less worthwhile than men. Woolf, however, turned her attention to the ways in which everyday life can stop even geniuses from producing great art. Although her focus was specifically on women, Woolf's views on how closely art is rooted in real life anticipate one of the major trends in twentieth-century criticism. *A Room of One's Own* helped fundamentally shift views of "artistic genius" in literary criticism and beyond.

Today, nearly 90 years after it was first published, *A Room of One's Own* remains a relevant and important text. Though life has improved for women in Britain and elsewhere over the last century, many of Woolf's arguments are still valid. Her portrayal of the effects of everyday life on the mind provides a useful framework for thinking about social groups suffering the effects of prejudice. For any reader interested in feminism or literary criticism it is a seminal text.

SECTION 1
INFLUENCES

MODULE 1
THE AUTHOR AND THE HISTORICAL CONTEXT

KEY POINTS

- *A Room of One's Own* is a crucial document in the history of the intellectual and social movement of feminism,* and one of the most influential pieces of twentieth-century feminist literary criticism.

- Virginia Woolf's upbringing gave her a privileged access to education but deprived her of the opportunities extended to her brothers.

- After the initial victories of first-wave feminism* (the feminist activism of the nineteenth and early twentieth century that largely focused on basic equalities under the law), Woolf saw that the battle for equality was as much about the basic conditions of life in British society as it was about legal rights.

Why Read This Text?

Virginia Woolf's *A Room of One's Own* (1929) is a seminal text in the history of feminist thought, by a writer regarded as the most important female novelist of the twentieth century. The essay helped expand the debate on women's equality beyond constitutional legal issues such as voting rights. It examined the deep psychological effects of the conditions of everyday life on women, and on female writers in particular.

The feminist debates of the early twentieth century had concentrated largely on the gaining of key legal rights for women—in particular women's suffrage* (the right to vote in national

> **❝**I am back from speaking at Girton,* in floods of rain. Starved but valiant young women—that's my impression. Intelligent, eager, poor; and destined to become schoolmistresses in shoals.**❞**
>
> Virginia Woolf, *A Writer's Diary*

elections). But *A Room of One's Own* concentrated on the impact of daily life on women's psyches and talents. The essay tries to answer the question of why the literary canon* (the set of works generally agreed to be literary classics) contains so few works by women writers. Working from the cultural materialist* proposition that art is closely linked to "material" life—a person's economic circumstances, clothes, access to private space, interactions with other people—Woolf suggests that potential women writers throughout history have been prevented from writing by material conditions that persistently privilege men. How, Woolf asks, can history's women have been expected to produce literature when deprived of money, privacy, and education?

When *A Room of One's Own* was published it helped create a profound change in feminism. It is still an intellectually rich and thought-provoking work. Ahead of its time, its central themes became major questions for feminists throughout the second half of the twentieth century, and remain relevant today. Providing a vital insight into Virginia Woolf's own work as well as into early feminist thought, it remains a key text for students of literature and feminism.

Author's Life

Virginia Woolf was born on January 25, 1882 in Kensington, London, the third child of Sir Leslie* and Julia Stephen. Woolf's siblings were Vanessa* (born 1879), Thoby* (1880), and Adrian* (1883). Her brothers went to boarding school and later to the

University of Cambridge;* the girls were home-schooled. In their father's library, however, they had access to a wide selection of books. Virginia gained a deep knowledge of English literature and the classics, which laid the ground for her development as a writer.

After their father's death in 1904, she and her siblings moved to Bloomsbury Square in London. There they became friends with the artists and intellectuals later known as the Bloomsbury Group.* Together with the Stephens, the group included the novelist E. M. Forster,* the economist John Maynard Keynes,* and the biographer Lytton Strachey,* among others. In 1912, Virginia married one of that circle, Leonard Woolf,* taking the name by which she became known.

Virginia Woolf's writing career began in 1900 with journalism, and she started work on her first novel in 1907. That book—*The Voyage Out* (published 1915)—was followed by eight more, including *Mrs Dalloway* (1925), *To the Lighthouse* (1927), and *The Waves* (1931). Of her nonfiction the best-known works remain *Modern Fiction* (1919) and *A Room of One's Own* (1929). Her books made Woolf a literary celebrity within her lifetime, and today she is accepted as one of the twentieth century's greatest writers.

In an age when literary fame and intellectual respect were rarely achievable for women, Woolf was acutely aware of the difficulties women faced, and the psychological consequences of being a talented woman in a generally misogynistic* (woman-hating) society. Subject to bouts of mental illness and suicide attempts throughout her life, Woolf committed suicide in 1941, shortly after completing her final novel, *Between The Acts*, which was published posthumously.

Author's Background

The 1920s were a pivotal time for Britain, for British women, and for the arts.[1] The United Kingdom was the major world power, maintaining an empire of approximately 450 million subjects—one-

fifth of the world's population—and it reaped the economic benefits of its dominance.[2] Technological changes, such as radio, provoked a fascination with the possibilities of modern media, which began to have important effects on the arts and everyday life.[3] But at the same time, Britain was a wounded nation, suffering from the physical and psychological effects of World War I* (1914–18).

With over 700,000 British servicemen dead—approximately 35 percent of males aged 19 to 22—the war caused huge social changes, particularly for women.[4] In 1918, women over 30 gained the right to vote. In 1928 this was extended to all women over 21 in a parliamentary act that was passed just two months before Woolf delivered the lectures upon which *A Room of One's Own* is based. Many of the female undergraduates whom Woolf addressed in 1928 were part of a new generation of young female students and women who were working outside the home in greater numbers than ever before.

There were still many obstacles to women's rights, however, and women remained vastly less valued than men by society, and vastly less materially well-off. At the time of Woolf's visit to Cambridge, for instance, female students were still not full members of the university. They would not be full members until 1948.[5]

NOTES

1 For a concise, in-depth overview of Woolf's historical context see Michael H. Whitworth, *Virginia Woolf* (Oxford: Oxford University Press, 2005), ch. 2, passim.

2 Angus Maddison, *The World Economy: A Millennial Perspective* (Paris: Organisation for Economic Co-operation and Development, 2001), 98.

3 See Tapan K. Sarkar et al., *History of Wireless* (Hoboken, NJ: Wiley-Interscience, 2006).

4 See John Keegan, *The First World War* (New York: Vintage, 2000), 439.

5 For a full history see Rita McWilliams-Tullberg, *Women at Cambridge: A Men's University, Though of a Mixed Type* (London: Gollancz, 1975).

MODULE 2
ACADEMIC CONTEXT

KEY POINTS

- The position and lives of women in patriarchal* (male-dominated) society was, and remains, a central question in the intellectual and political movement of feminism.*

- While legal rights were the main focus of early feminism, the idea that repressive social conventions and lack of education contributed substantially to women's lower status had been present since the early feminist thinker Mary Wollstonecraft's* *Vindication of the Rights of Woman* (1792).

- Unlike many of her contemporaries, Virginia Woolf focused on the effects of everyday existence on women, particularly women writers, and suggested that these "material conditions" were of more significance than legal rights.

The Work in its Context

Virginia Woolf's *A Room of One's Own* should be seen in three intellectual contexts: Woolf's own intellectual background, the history of feminism, and the history of literature.

Woolf benefited from personal ties to the literary and intellectual elite of the period. Her father, Leslie Stephen,* was a journalist, biographer, and historian of ideas, now best known for founding the *Dictionary of National Biography*. Thanks to his learning, Woolf grew up in a rich intellectual environment. Further links to the intellectual elite came through her brothers Adrian* and Thoby* Stephen who, at the University of Cambridge,* became friends with the gifted thinkers who later formed the core of the

> ❝ Have you any notion of how many books are written about women in the course of one year? Have you any notion how many are written by men? Are you aware that you are, perhaps, the most discussed animal in the universe? ❞
>
> Virginia Woolf, *A Room of One's Own*

circle of intellectuals and artists known as the Bloomsbury Group.*

Feminism was also at a turning point intellectually. Increased rights for women were often met by a hardening of old social prejudices against them, and there were intense debates about the nature of women within feminist circles. As the English literature scholar Michael Whitworth points out, immediately after partial voting rights were achieved in 1918, divisions appeared between "old" and "new" feminism.[1] The former saw women as deserving equal rights because—as humans—they were essentially the same as men. The latter sought parity but emphasized gender difference. These debates lay behind *A Room*'s questioning of mental "androgyny"*—what it might mean to have a mind that is neither male nor female, or perhaps both.[2]

Lastly, during the first decades of the twentieth century the movement of modernism* had overturned and reinvigorated traditional forms in fields such as architecture and music. The decade following 1918 saw huge developments in English-language literature. We can consider James Joyce's* novel *Ulysses* (serialized in 1918; published as a book in 1922), T. S. Eliot's* long poem *The Waste Land* (1922), and the poet and novelist D. H. Lawrence's* *Lady Chatterley's Lover* (1928) to be landmark modernist texts. A crucial element of modernism, as Eliot argued in his important essay "Tradition and the Individual Talent" (1919), was its relationship to tradition and the literary canon.* This preoccupation was crucial to Woolf's thinking on a possible female canon in *A Room of One's Own*.[3]

Overview of the Field

A Room of One's Own belongs to three different fields: it is simultaneously a feminist polemic (a controversial argument), an essay in literary theory, and a work of fiction. It draws on and responds to influences from each of these fields.

Feminism—often referred to as "The Women's Question"—was a key topic of debate in early twentieth-century Britain, and Woolf had precedents to draw on when considering the place of women writers in the world. In *A Vindication of the Rights of Woman* (1792) the pioneering feminist Mary Wollstonecraft had argued that a lack of education stood in the way of women's ability to be equal members of society.[4] The American feminist Margaret Fuller's* well-known 1843 work *Woman in the Nineteenth Century* also argued powerfully for women's rights to education and professional roles. In examining the relationship between women's economic circumstances and their ability to produce literature, Woolf was following in both women's footsteps.

A Room of One's Own also has precedents in literary theory and the development of fiction. T. S. Eliot's "Tradition and the Individual Talent" had helped crystalize modernism's fascination with past literary precedents: the "tradition." For Eliot, every writer must write from a deep knowledge of the great writers before him—an idea that became a mainstay of Anglo-American literary criticism from the 1930s onward. Woolf's contention that women writers need their own "forerunners" is part of this shift. Elements of modernism can also be seen in the form and style of *A Room*. A hybrid of essay and fiction, the piece's immersion in the consciousness and perception of its narrator is a hallmark of modernist narrative, and of Woolf's own novels.

Academic Influences

Though it is difficult to trace the direct influence of early feminist writers on *A Room of One's Own*, the essay is shaped by the feminist

thought of its time. As the scholar Sowon Park of Oxford University has noted, many of its arguments were "very much in the air" thanks to writers such as the British actor and feminist Cicely Hamilton* and Charlotte Perkins Gilman* of the United States.[5] Anticipating Woolf's invention of "Judith Shakespeare" (a fictional sister for William Shakespeare),* Hamilton's 1909 *Marriage as a Trade* had debated why there were no female equivalents to Shakespeare.[6] Gilman, meanwhile, attacked the psychological effects of women's subjugation by men in her *The Man-Made World: Or, Our Androcentric Culture* (1911).[7]

More broadly, Woolf's influences came from the close circle of the Bloomsbury Group and the other artists with whom she associated. Through writing reviews, publishing at the Hogarth Press* (run by Woolf and her husband), and in personal interactions, she encountered the work of T. S. Eliot and James Joyce. The Bloomsbury Group itself was a melting pot for radical ideas and an experimental approach to art, thought, and sexuality—all of which can be traced in *A Room of One's Own*. Members of the group, such as economist John Maynard Keynes,* biographer Lytton Strachey,* art critic Clive Bell,* and painter Roger Fry,* were at the forefront of radical movements in their fields. Together they questioned the prevailing attitudes of the time, and their influence is pervasive in *A Room*, as in Woolf's work more generally.[8]

NOTES

1 Michael H. Whitworth, *Virginia Woolf* (Oxford: Oxford University Press, 2005), 62.

2 Virginia Woolf, *A Room of One's Own* and *Three Guineas*, ed. Anna Snaith (Oxford: Oxford University Press, 2015), 74.

3 T. S. Eliot, "Tradition and the Individual Talent," in *Selected Essays* (London: Faber & Faber, 1951).

4 See Mary Wollstonecraft, *A Vindication of the Rights of Woman*, ed. Deidre Shauna Lynch (New York: W. W. Norton, 2009).

5 Sowon S. Park, "Suffrage and Virginia Woolf: 'The Mass Behind the Single Voice'," *The Review of English Studies* 56, no. 223 (2005): 122.

6 Cicely Hamilton, *Marriage as a Trade* (New York: Moffat, Yard and Co.,1909), chs. 14–16.

7 Charlotte Perkins Gilman, *The Man-Made World: Or, Our Androcentric Culture* (New York: Charlton, 1911).

8 There is an extensive bibliography on Bloomsbury: see Frances Spalding, *The Bloomsbury Group* (London: National Portrait Gallery, 2005); Rae Gallant Robbins, *The Bloomsbury Group: A Selective Bibliography*, 1st edn (Kenmore, WA: Price Guide Publishers, 1978); Heinz Antor, *The Bloomsbury Group: Its Philosophy, Aesthetics, and Literary Achievement* (Heidelberg: C. Winter, 1986).

MODULE 3
THE PROBLEM

KEY POINTS

- Virginia Woolf's essay examines two central questions: why are there so few female writers in the literary canon?* And what conditions are required for women to write great fiction?

- When Woolf was writing, the lack of famous female writers and artists through history was frequently cited as proof of women's intellectual inferiority.

- Woolf tackled this assumption by examining how social and material conditions through the ages had effectively silenced women writers.

Core Question

Virginia Woolf's *A Room of One's Own* was originally entitled "Women and Fiction" but, as Woolf states in its opening, the work deliberately leaves unanswered "the great problem of the true nature of woman and the true nature of fiction."[1] Instead, Woolf addressed two core questions: why are there so few women writers in the literary canon? And what conditions are required for women to produce great literature?

The first of these countered a key assumption of much antifeminist* rhetoric of the time: that women were less intelligent and able than men. The lack of famous female authors throughout history was frequently taken as evidence for such assumptions. Woolf, however, assumes equal intelligence and talent across the sexes, and asks instead what historical conditions had prevented women from becoming great writers. By seeking the real causes of the sparse feminine literary tradition, she was trying to counter the claim that women lacked literary ability.

> ❝ I thought how unpleasant it is to be locked out; and I thought how it is worse perhaps to be locked in; and thinking of the safety and prosperity of the one sex and the poverty and insecurity of the other and of the effect of tradition and of the lack of tradition upon the mind of a writer, I thought at last it was time to roll up the crumpled skin of the day. ❞
> Virginia Woolf, *A Room of One's Own*

The second core question related to the ongoing project of the women's movement* in Britain (a term often used for the struggle for women's suffrage* and for the early feminist* movement). Despite receiving full suffrage in 1928, just two months before the lectures that became *A Room of One's Own*, women were still subject to persistent inequalities and prejudices. Social expectations (such as those relating to education, marriage, and work), institutional bylaws (such as those preventing female students at the University of Cambridge* from being able to receive degrees until 1948), and material conditions (lack of money or privacy) still relegated women to a secondary position in British society. What changes, Woolf asked, would be necessary for women to be able to produce great literature, as men had throughout history?

The Participants

"The Women's Question" was the subject of heated debate in Woolf's time. Even as women's legal rights were increased, social conventions lagged. As the South African novelist and feminist Olive Schreiner* noted in her 1911 book *Women and Labour*, women were "bound hand and foot ... by artificial constrictions and conventions, the remnants of a past condition of society."[2] Though World War I* had brought increased opportunities (and

needs) for women to find work outside the domestic sphere, their progress beyond their traditional roles had caused an antifeminist and even misogynist*—"women-hating"— backlash.

In *A Room of One's Own*, Woolf caricatures this backlash in the fictional "Professor von X," and his "monumental work" entitled *The Mental, Moral, and Physical Inferiority of the Female Sex*.[3] Real antifeminists were hardly less extreme. In the late nineteenth century, the Harvard medical professor Edward Clarke* had suggested that a "masculine" education would physically damage women.[4] In Woolf's own time, the Austrian philosopher Otto Weininger's* *Sex and Character* (1903) stated that human characters were composed of the mixture of two "elements," the "male" and the "female"—the "female" only accounted for negative qualities.[5]

On the other side of the debate were pioneering feminists such as Olive Schreiner, Elizabeth Robins,* Eleanor Rathbone,* and Ray Strachey.*[6] Together with organizations such as the London Society for Women's Suffrage, Britain's first organization to campaign for women's right to vote on a national level, they were active in promoting both the campaign for full voting rights and a broader feminist outlook.

The Contemporary Debate

The debate on women's rights centered on the widespread assumption that women were either inferior to men or "naturally" different in ways which suited them to certain activities and excluded them from others. Clarke's *Sex in Education* (1873) is a good example of the latter position. Clarke's text was a touchstone for the pathology and medicalization of "Womanhood"—that is, for rendering femininity a diagnosable medical condition—and remained influential in the 1920s. "Man," Clarke stated, "is not superior to woman, nor woman to man," but there were "natural" differences, which could not be ignored.[7] Subjecting a girl to a "boy's [school] regimen," for instance,

would end up "deranging the tides of her organization." Therefore, said Clarke, "identical education of the sexes is a crime before God and humanity."[8]

Otto Weininger was more straightforwardly misogynistic: the "female element" was purely negative, and any positive quality in a woman was a sign of "maleness." "All women who are truly famous and are of conspicuous mental ability," he wrote, possess "some of the anatomical characters of the male." Their maleness was the source of all their impressive qualities.[9] In regard to women and art, he was similarly direct: "there is no female genius ... *and there never can be one*."[10] Such a thing would be "a contradiction in terms, for genius is simply intensified ... universally conscious maleness."[11]

The women's movement itself was home to a range of opinions on women's rights and capabilities. But one common theme, as Schreiner argued, was that women had been unnaturally forced into a condition of "parasitism" (dependency on men) by social conditions and exclusions that made woman "the lesser sex" by robbing her "of all forms of active, conscious, social labour, and [reducing] her ... to the passive exercise of her sex functions alone."[12]

NOTES

1 Virginia Woolf, *A Room of One's Own* and *Three Guineas*, ed. Anna Snaith (Oxford: Oxford University Press, 2015), 4.

2 Olive Schreiner, *Woman and Labour* (London: T. Fisher Unwin, 1911), 24.

3 Woolf, *A Room of One's Own*, 24.

4 See Edward H. Clarke, *Sex in Education; or, A Fair Chance for Girls* (1873), in Nancy F. Cott, *Root of Bitterness: Documents of the Social History of American Women* (Lebanon, NH: University Press of New England, 1996), 331.

5 See Otto Weininger, *Sex and Character* (London: William Heinemann, 1906).

6 Sowon S. Park, "Suffrage and Virginia Woolf: 'The Mass Behind the Single Voice'," *The Review of English Studies* 56, no. 223 (2005): 122–3.

7 Clarke, *Sex in Education*, 330.

8 Clarke, *Sex in Education*, 331.

9 Weininger, *Sex and Character*, 65

10 Weininger, *Sex and Character*, 189.

11 Weininger, *Sex and Character*, 189.

12 Schreiner, *Woman and Labour*, 78.

MODULE 4
THE AUTHOR'S CONTRIBUTION

KEY POINTS

- Virginia Woolf suggested that for women to produce great literature they needed to have a steady income and a private space of their own.

- Woolf's suggestion that material circumstances were vital to the production of literature reinforced the idea that women were no less intrinsically able to produce great writing than men, but had instead been prevented from doing so by their conditions.

- While Woolf was taking on ideas already in the main current of the women's movement* at the time, her approach to expressing them was deeply original.

Author's Aims

Virginia Woolf's *A Room of One's Own* grew out of two lectures given in October 1928 at Newnham College* and Girton College,* then the two women-only colleges of the University of Cambridge.* Returning from Cambridge after the Girton lecture, Woolf wrote in her diary that she "blandly told them to drink wine and have a room of their own"—a tired and joking comment that actually cuts to the heart of her aim to show how female writers could only achieve greatness under conditions of *material* equality with men.[1] That is to say, that while women had made some strides toward the full legal equality (such as voting rights and workplace equality) that had not been granted to them before, they were still materially worse off than men: they generally had less money, less comfortable lives, and less privacy.

❝ But, you may say, we asked you to speak about women and fiction—what has that got to do with a room of one's own? I will try to explain. ❞

Virginia Woolf, *A Room of One's Own*

Woolf aimed to show the negative impact these material inequalities had on women in general, and women writers in particular. In the final text of *A Room of One's Own*, Woolf comes to this central aim through four subsidiary aims: to show why there were so few female writers in the past; to show how this lack of a female literary tradition affected present-day women writers; to show the range of ways in which women found themselves literally and metaphorically locked into certain spaces (the home, for instance), and locked out of others (male-only institutions); and to show how the basic conditions of life affect people's consciousness and abilities.

Though many of these ideas were in the air at the time, Woolf's focus on the effects of material conditions on women through literature was deeply original. As the English literature scholar Laura Marcus suggests, *A Room of One's Own* remains perhaps "the most significant model for feminist* criticism" in the twentieth century.[2]

Approach

Although the book grew out of lectures, *A Room of One's Own* is a complex mixture of essay and short fiction. The text begins in mid-sentence ("But, you may ask"), as if the reader has walked in, late, to a lecture. The narrator then goes on to say that she is going to use "all the liberties and licences of a novelist" to approach her subject. What follows is a fictional record of the narrator's experiences in Cambridge (dining at a male college and at a women's college) and in London (researching for the lecture, reading a contemporary

female writer's novel), along with a thought experiment, in which the narrator imagines the possible life of a talented woman of Elizabethan* Britain (the Britain of Queen Elizabeth I, who reigned between 1558 and 1603).

Woolf chooses this original approach as a means of combining critical insights about female writers and their place in history with a first-hand account of her female experience as a writer. It allows her to access both the analytical logic and historical evidence of traditional literary criticism and the emotional resources of narrative fiction. It also means she can contribute to, and critically investigate, the "Women's Question" in a different mode from the impassioned political arguments of writers as Olive Schreiner.* Woolf encourages the reader's engagement with the narrator as a primary way of understanding and relating to her argument.

Another key element of Woolf's approach is her focus on the material conditions of life. The narrator's statement that having money "seemed infinitely more important" than having the vote has been controversial.[3] What it emphasizes, however, is Woolf's cultural-materialist* belief—the assumption that human capabilities are intimately related to their economic circumstances, and to even the smallest material aspects of life.

Contribution in Context

As Laura Marcus has noted, *A Room of One's Own* became a key text for feminists and feminist literary criticism in the second half of the twentieth century because of its forward-looking focus on personal rather than political issues.[4] However, as the scholars Sowon Park and Alex Zwerdling both point out, although *A Room* is original in many ways, it is also very much a product of Woolf's engagement with ideas that were already present in feminist writings.

Zwerdling notes that Woolf was "conscious of writing in a tradition that had begun over a century before with Mary Wollstonecraft's* *A*

Vindication of the Rights of Woman and had continued well into her youth and adulthood."[5] Yet, at the same time, he points out, "her attitude toward the feminist legacy was essentially revisionist."[6] This was particularly the case in regard to the suffrage movement of Woolf's youth, which had become focused almost solely on the issue of women's votes in the belief that the other changes women desired would then follow. Woolf was openly skeptical about this, believing that "the psyche was much more resistant to change than the law." In other words, things would not really change until social attitudes and material conditions allowed women's and men's minds to see themselves and each other as equal.

Though the legal aspects of women's liberation were still an ongoing project, key rights had been won by 1928. Woolf, however, was more interested in the psychological and economic causes of continuing masculine domination. *A Room of One's Own* moved the focus of feminism back to a broader and more complex set of issues than just legal rights; a shift that should be seen as both part of a feminist tradition, and an original step in its immediate context.

NOTES

1 Virginia Woolf, *A Writer's Diary*, ed. Leonard Woolf (London: Harcourt, 1954), 134.

2 Laura Marcus, *Virginia Woolf*, 2nd edn (Tavistock: Northcote House, 2004), 43.

3 Virginia Woolf, *A Room of One's Own* and *Three Guineas*, ed. Anna Snaith (Oxford: Oxford University Press, 2015), 29.

4 Marcus, *Virginia Woolf*, 41.

5 Alex Zwerdling, *Virginia Woolf and the Real World* (Berkeley: University of California Press, 1986), 211.

6 Zwerdling, *Woolf and the Real World*, 211.

SECTION 2
IDEAS

MODULE 5
MAIN IDEAS

KEY POINTS

- The central theme of *A Room of One's Own* is that women throughout history have been prevented from fulfilling their potential by the economic and material disadvantages created by patriarchal* (male-dominated) society.

- Virginia Woolf argues that for women to write fiction—and enter into the literary canon*—they must have a steady income and private space.

- Woolf presents this idea through a fictional account of experience as a woman in the early twentieth century, and through an examination of women's lives and writing from the sixteenth century onwards.

Key Themes

The central theme of Virginia Woolf's *A Room of One's Own* is that, as Woolf states: "Intellectual freedom depends upon material things."[1] She sums this up in the memorable phrase that gives the essay its title "a woman must have money and a room of her own if she is to write fiction."[2] Even more precisely, she sets the figure at an income of £500 a year—the equivalent of just over £28,000 (more than $43,000) today.[3]

Woolf's demand is both literal and symbolic: these are real requirements as far as she is concerned, but they also represent larger things. The money "stands for the power to contemplate ... a lock on the door means the power to think for oneself."[4] Her main argument is that intellectual development, specifically talent for writing, is dependent not on a romantic notion of innate genius

> ❝ [These] webs are not spun in mid-air by incorporeal creatures, but are the work of suffering human beings, and are attached to grossly material things, like health and money and the houses we live in. ❞
>
> Virginia Woolf, *A Room of One's Own*

but on the most basic conditions of life: the food you eat, the clothes you wear, the spaces in which you can move or not move, how you are allowed and expected to act by social convention.

This idea lies behind the narrator's controversial notion that money and private space are more important than voting rights. To illustrate this, the narrator quotes the contemporary literary critic Sir Arthur Quiller-Couch,* stating "we may prate of democracy, but actually, a poor child in England has little more hope than the son of an Athenian slave to be emancipated into that intellectual freedom of which great writings are born."[5] For the narrator, her female contemporaries are like Quiller-Couch's poor child: "women have always been poor ... have had less intellectual freedom than the sons of Athenian slaves."[6] Even with the right to vote, the more important form of "intellectual emancipation" cannot be found without their economic and material circumstances improving.

Exploring the Ideas

The central feature of Woolf's argument in *A Room of One's Own* is cultural materialism*: the idea that the characters, intellectual abilities, and beliefs of individuals are formed by the social structures and economic conditions of their world. This is to say, too, that the culture of a society—from popular songs through to newspapers, art, poetry, and fiction—is directly informed by the "material conditions" of life in that society: how much individuals earn, the

education they have access to, the houses they can afford to live in, the food they can afford to eat. This contrasts starkly with the common view that "art" is the product of extraordinary individuals whose minds are able, as Woolf puts it, "to rise above such things."[7] Believing that it is possible to do so, Woolf suggests, is to ignore the impact of everyday realities on the artist.

Alongside the cultural-materialist underpinning of Woolf's argument is the belief that great art comes from a tradition. This is a notion at the heart of the modernist* movement in literature, vocally put forward by Woolf's contemporaries Ezra Pound* and T. S. Eliot,* and expressed in the literary allusions of texts such as James Joyce's* celebrated novel *Ulysses*. In Woolf's words, "masterpieces are not single and solitary births; they are the outcome of many years of thinking in common, of thinking by the body of the people, so that the experience of the mass is behind the single voice."[8] In other words, all writers are dependent on their forerunners.

These ideas come together to explain the lack of women writers through history. First, male-dominated society—"patriarchy" in the standard feminist* terminology—has consistently deprived women of the economic independence and physical privacy necessary to allow them to write. Second, this has denied those rare women in a material position to write the female literary tradition necessary to help them create great literature. That there are so few great female writers, historically, is not evidence that women cannot write; it is only evidence that they have been prevented from writing by their social circumstances.

Language and Expression

Although *A Room of One's Own* is an accessible text, its form is intriguing. It combines aspects of critical writing and lectures with techniques from fiction—most notably Woolf's use of a narrator. Though written in the first person, with the narrator speaking as "I,"

Woolf makes clear that that "I" is not meant to be the author herself: "Here then was I (call me Mary Beton, Mary Seton, Mary Carmichael or by any name you please—it is not a matter of importance)."[9] Woolf uses the device to show that women in 1920s society are in no better a situation than their ancestors, and also that they are treated in many ways as identical and interchangeable by patriarchal society even though they are named individually. This is a central motif of her argument. The three names, taken from a sixteenth-century ballad, all appear elsewhere in the essay, as the narrator's aunt, as the principal of the fictional "Fernham" College, and as a female novelist. The device also allows Woolf to synthesize many elements of real, lived female experience and present them to the reader vividly, as though firsthand, through the fictional experience of the narrator.

Beyond its formal inventiveness, which shares much with Woolf's novels, *A Room of One's Own* makes as much use of humor and irony as it does of direct critical analysis of its subject. Woolf's narrator openly satirizes the kind of male "authority" who writes misogynist* literature as if it were scientific fact. She presents a cutting portrait of "Professor X," imagined as "not in my picture a man attractive to women ... he had a great jowl ... very small eyes; he was very red in the face."[10] Elsewhere, writing of "all those great men" who have loved women across history (despite women's apparently clear inferiority) the narrator notes ironically that "all these relationships were absolutely Platonic [i.e., not sexual] I would not affirm."[11] A similar dry, sharp humor appears throughout the text.

NOTES

1 Virginia Woolf, *A Room of One's Own* and *Three Guineas*, ed. Anna Snaith (Oxford: Oxford University Press, 2015), 81.

2 Woolf, *A Room of One's Own*, 3.

3 According to the Bank of England's inflation calculator: http://www. bankofengland.co.uk/education/Pages/resources/inflationtools/calculator/ flash/default.aspx, accessed August 5, 2015.

4 Woolf, *A Room of One's Own*, 80.

5 Woolf, *A Room of One's Own*, 81; original source Arthur Quiller-Couch, *On the Art of Writing* (New York: G. P. Putnam's Sons, 1916), 39.

6 Woolf, *A Room of One's Own*, 81.

7 Woolf, *A Room of One's Own*, 81.

8 Woolf, *A Room of One's Own*, 49.

9 Woolf, *A Room of One's Own*, 4.

10 Woolf, *A Room of One's Own*, 24.

11 Woolf, *A Room of One's Own*, 65.

MODULE 6
SECONDARY IDEAS

KEY POINTS

- The two key secondary ideas of *A Room of One's Own* are that it might be possible to imagine or uncover a hidden female literary canon* and that writing has a close, complex relationship with gender.

- The first of these ideas underpins the argument that women throughout history have been prevented from writing by their circumstances; the second allows Virginia Woolf to question what a female canon would or should look like.

- The alternative women's history of literature has proved extremely influential for later feminist* literary criticism.

Other Ideas

One of the most influential aspects of Virginia Woolf's *A Room of One's Own* is Woolf's thought experiment on "Judith Shakespeare." A fictional sister to William Shakespeare,* Woolf's Judith illustrates the ways in which women's voices have been silenced or suppressed throughout history. As Woolf notes, this suppression is neither simple nor deliberate. It is complex and indirect: Judith's father discourages her from reading precisely because he loves her, and does not want her to suffer social exclusion.[1] Like her brother, she escapes to London to follow her dream of writing and acting. But unlike William, she is laughed at and excluded, and eventually, pregnant with an illegitimate baby, she kills herself.[2] Woolf uses this imagined life to interrogate how and why history presents so few examples of female writers.

Moving on from "Judith Shakespeare," Woolf's narrator charts the few women writers in English who constitute the sparse "female

> 66 Let me imagine that Shakespeare had a wonderfully gifted sister, called Judith, let us say ... She was as adventurous, as imaginative, as agog to see the world as he was. But she was not sent to school. 99
>
> Virginia Woolf, *A Room of One's Own*

tradition" in literature: Aphra Behn,* the Brontë* sisters, Jane Austen,* George Eliot.* Women's "creative power," the narrator initially suggests, "differs greatly from the creative power of men," and women's writing should reflect that difference.[3] Later, however, the narrator asks herself whether or not writing should be gendered in this way. If there are "two sexes in the mind corresponding to the two sexes in the body" might they "also require to be united in order to get complete satisfaction and happiness," so that they may create great literature?[4] If so, does such a union undo the idea of "female writing" or a possible "female canon"?

Exploring the Ideas

"Judith Shakespeare" is central to the argument in *A Room of One's Own* about the suppression of women's voices. The invention of a female counterpart to the greatest writer in English history is used by Woolf to illustrate that, regardless of her natural talents, a woman in Shakespeare's time could never have become "Shakespeare." "Judith" also illustrates the complex and indirect nature of women's suppression: she is not silenced deliberately, or out of conscious hatred by men, but by social conditions. She "was the apple of her father's eye," and "Nick Greene ... took pity on her"; the men in her life act with good intentions, but within a context that can only lead to Judith's subjugation and silencing.[5] Woolf extends this to say that it was impossible for a real sixteenth-century woman to

have "Shakespeare's genius," as genius "is not born among laboring, uneducated, servile people," and such was the condition of women at the time.[6]

While *A Room of One's Own* attacks deliberate misogyny*— the "anger disguised and complex" behind Professor X's hatred, for instance—Judith's suppression emphasizes the widespread nature of male-dominated society's unconscious, unintended, subjugation of women. Elsewhere Woolf expresses this in the ironically polite figure that prevents the narrator from entering the library in the all-male college she visits. He is "a guardian angel," "a deprecating, silvery kindly gentleman" who "regretted" that women cannot enter the library without a college fellow, or a letter of introduction.[7]

This view provides Woolf with a way to imagine what has been lost through women's "infinitely obscure lives," to imagine a continuous forced silence beneath the noise of male history.[8] This is one of the text's most enduring contributions to feminist literary criticism, with Woolf asking the reader to imagine the possibilities disguised by that silence: "When ... one reads of a witch being ducked, or a woman possessed by devils, of a wise woman selling herbs ... then I think we are on the track of a lost novelist, a suppressed poet, of some mute and inglorious Jane Austen."[9] This muteness still leaves open, for Woolf, the question of what a true "women's fiction" would resemble—a question which leads directly to one of the essay's less-discussed ideas: literary androgyny.*

Overlooked

In a text as brief and influential as *A Room of One's Own* it is hard to talk of overlooked ideas, but the narrator's thoughts on whether writing can or should be "gendered" (i.e. male or female) remain more ambiguous and puzzling than the central claims of the essay. These ideas are occasionally sidelined in discussions of the text. Importantly, though, they make possible a lesbian reading of the

work, placing *A Room* as an early "queer"* text (i.e. a text in the recently named theoretical and cultural current of inquiry into identities outside the heterosexual "norm") as well as an early feminist text.

In chapter 5, the narrator argues that a "women's fiction" can only come out of a female tradition, because women's "creative power differs greatly" from men's.[10] Later, she questions this idea. Seeing a couple getting into a London taxi together makes her wonder "whether there are two sexes in the mind" as well as in the body, and whether they must be balanced together for "complete satisfaction and happiness" in literature, as in life.[11] If so, should there be such a thing as "female" writing, or should all writers be "androgynous"—simultaneously male and female?

The idea of the "man-womanly" or "woman-manly" mind, of the coexistence of "female" and "male" elements, was a common theme of contemporary theories on sex—including, notably, the Austrian philosopher Otto Weininger's misogynist work *Sex and Character*, with which Woolf was familiar.[12] "Androgyny" was frequently associated with homosexuality—as in Weininger's presumption that the Classical lesbian poet Sappho* (circa 630–570 B.C.E.) was more male than female.[13] Woolf was aware that readers might see a lesbian subtext in *A Room of One's Own,* writing in her diary before the essay's publication that she would be "hinted at for a Sapphist" (i.e. a lesbian).[14] Though it remains only the hint of a theme in the essay itself, lesbianism was an important aspect of Woolf's own sexuality. Her 1928 novel *Orlando*, about a character who changes sex over the course of an unnaturally long life, was, as Laura Marcus notes, "a very public 'love-letter'" to her then lover Vita Sackville-West.*[15] As such, the brief reflection on literary "androgyny" represents an important gesture not just toward "women's writing" but also toward what would come to be known as "queer writing."

NOTES

1 Virginia Woolf, *A Room of One's Own* and *Three Guineas*, ed. Anna Snaith (Oxford: Oxford University Press, 2015), 36.

2 Woolf, *A Room of One's Own*, 36–7.

3 Woolf, *A Room of One's Own*, 66.

4 Woolf, *A Room of One's Own*, 74.

5 Woolf, *A Room of One's Own*, 36, 37.

6 Woolf, *A Room of One's Own*, 37.

7 Woolf, *A Room of One's Own*, 6.

8 Woolf, *A Room of One's Own*, 67.

9 Woolf, *A Room of One's Own*, 37.

10 Woolf, *A Room of One's Own*, 66.

11 Woolf, *A Room of One's Own*, 74.

12 Otto Weininger, *Sex and Character* (London: William Heinemann, 1906).

13 Weininger, *Sex and Character*, 66.

14 Virginia Woolf, *A Writer's Diary*, ed. Leonard Woolf (London: Harcourt, 1954), 148.

15 Laura Marcus, *Virginia Woolf*, 2nd edn (Tavistock: Northcote House, 2004), 55.

MODULE 7
ACHIEVEMENT

KEY POINTS

- Virginia Woolf's *A Room of One's Own* was popular with contemporary readers and went on to influence generations of feminists.*

- The critical success of Woolf's novels helped the essay find a wide audience, and gave extra credibility to Woolf's arguments.

- While *A Room* remains a powerful text with potential applications in other contexts, its main limitation is that its arguments are specific to 1920s Britain.

Assessing the Argument

One important early reviewer of Virginia Woolf's *A Room of One's Own*, the critic and novelist Arnold Bennett,* was quick to note that it has, at heart, a very simple "thesis"—that you must have £500 a year and a room with a lock on the door if you are going to write fiction or poetry. To Bennett, this was at best "disputable."[1] For Bennett, the great Russian novelist Fyodor Dostoevsky* and he himself were counterexamples. What Bennett's review misses, however, is the broader drift of Woolf's argument that "intellectual freedom depends on material things," and that women throughout history have been materially much worse off than men.[2] She vividly evokes not only how these material disadvantages were felt in earlier times, but also, through the use of a narrator, how they are felt in her own time. As a result, *A Room* makes a strong case for the fundamental argument that lies behind Woolf's apparently glib premise.

Beyond this thesis, however, *A Room of One's Own* is hard to

> **❝ [When]** I ask you to write more books I am
> urging you to do what will be for your good and
> for the good of the world at large. **❞**
>
> Virginia Woolf, *A Room of One's Own*

pin down. In Bennett's unsympathetic analysis, it is undisciplined
and full of "padding," because Woolf "talks about everything but
the thesis."[3] In a sense this is true: Woolf opens up many lines of
argument and approaches the core questions of "women and
fiction" from several angles, deliberately avoiding clear conclusions.
This, though, is crucial to the essay's mode of inquiry, and to the
complex issues it examines. In the opening paragraph—before the
narrator takes the stage—Woolf refers to the money and the room
as a "minor point."[4] By implication, the major points of the text
are its "unsolved problems"—"the true nature of woman and the
true nature of fiction."[5] Remaining open-ended on these topics is
crucial to the essay, and one reason why its arguments continue to
have implications for readers today.

Achievement in Context

Though Woolf was already a literary success when *A Room of One's
Own* was published in 1929, the essay helped establish her reputation
as one of the brightest literary stars of her time. Since 1925 she had
published three novels that established her as one of Britain's most
important novelists: *Mrs Dalloway* (1925), *To the Lighthouse* (1927), and
Orlando (1928). In 1927 her yearly income from her novels was just
over £500. After *Orlando,* her earnings from her books came to nearly
three times as much.[6] When *A Room* was published, it received positive
reviews and sold faster than any of her previous books.[7] In England,
the Hogarth Press* (run by Woolf and her husband, Leonard) printed
14,650 copies in the first six months after publication.[8]

A Room of One's Own has gone on to be an important text not just for Woolf studies, but in a number of different disciplines: women's studies, gender studies, queer* studies, literary theory, and feminist studies. As the Woolf scholar and feminist literary theorist Susan Gubar* points out, it has come to be "a classic—if not *the* touchstone text—in the history of feminism."[9] A crucial aspect of the text's success, as the scholar Alex Zwerdling notes, is that Woolf was able with her novelist's "powers of observation and divination to probe depths the earlier feminist writers had left largely unplumbed."[10] This allowed her, in the wake of women winning the right to vote in 1928, "to restore a sense of the complexity of the issues after the radical simplification that had seemed necessary for political action."[11] In other words, *A Room*, with its complex mixture of fiction, literary criticism, and historical analysis, shone a light on issues and problems that had otherwise been left in the dark.

Limitations

While many of the issues raised by Woolf in *A Room of One's Own* remain relevant to feminism and literary criticism today, the text is very much a product of its time. Although Woolf is sensitive to and critical of the ways in which society has silenced women throughout history, *A Room* is not interested in history's other silenced and suppressed groups. Writing as part of the white upper class in early twentieth-century Britain, Woolf tackles the plight of women, but has blind spots when it comes to women of other colors and classes.

Woolf's essay is deeply concerned with the importance of material things and economic security. But her implied audience is women who, though disadvantaged by their sex, were largely members of the privileged upper classes. Woolf was part of a class where the possibility of being left an inheritance of £500 a year, like the essay's narrator, was real. Women of the working classes were not so fortunate, suffering subjugation both as women and as members

of Britain's "lower classes." Woolf addresses herself to women who, like her, did not need to fear destitution, even if they were not in control of their own voices and destinies.

While Woolf's model of listening for the voices of the silenced has proved relevant to contexts in which race is central, another blind spot is that of color. The black American author and activist Alice Walker,* in her essay "In Search of Our Mothers' Gardens," critiques Woolf's lack of interest in nonwhite women. As the title of the essay suggests, Walker is interested, like Woolf, in a female tradition—her "mother's"—but hers is specifically an African American female tradition. Her "mothers" are women who, like the early African American poet Phillis Wheatley* (1753–84), were slaves. Like her white counterparts in the eighteenth century, Wheatley could not hope to have access to £500 and a room of her own, but her suppression went further than theirs: as a slave, she "owned not even herself."[12] Walker's essay seeks out the silenced black women around Wheatley, constructing her own alternative history of the voices suppressed by colonial society.

NOTES

1 See Arnold Bennett, "Queen of the High-Brows" (review of *A Room of One's Own*, *Evening Standard*, November 28, 1929), in *Virginia Woolf: The Critical Heritage*, ed. Robin Majumdar and Allen McLaurin (London: Routledge, 1975), 259.

2 Virginia Woolf, *A Room of One's Own* and *Three Guineas*, ed. Anna Snaith (Oxford: Oxford University Press, 2015), 81.

3 Bennett, "Queen of the High-Brows," 259.

4 Woolf, *A Room of One's Own*, 3.

5 Woolf, *A Room of One's Own*, 3.

6 Hermione Lee, *Virginia Woolf* (London: Vintage, 1997), 558.

7 Julia Briggs, *Virginia Woolf: An Inner Life* (Orlando: Harcourt, 2005), 235.

8 See "Note on the Text," in Woolf, *A Room of One's Own*, xxxvii.

9 Susan Gubar, "Introduction," in Virginia Woolf, *A Room of One's Own,* ed. Susan Gubar (Orlando: Harcourt, 2005), xxxvi.

10 Alex Zwerdling, *Virginia Woolf and the Real World* (Berkeley: University of California Press, 1986), 216.

11 Zwerdling, *Woolf and the Real World,* 217.

12 Alice Walker, *In Search of Our Mothers' Gardens: Womanist Prose* (London: Phoenix, 2005), 235.

MODULE 8
PLACE IN THE AUTHOR'S WORK

KEY POINTS

- Virginia Woolf was a prolific writer of both fiction and criticism, best known for her focus on the fine detail of human experience.

- Although *A Room of One's Own* is a short text in a productive career, it was a success in its own time, and remains Woolf's best-known critical work.

- Woolf's reputation rests, ultimately, on her novels, which rank among the most highly regarded works of twentieth-century literature; she is perhaps best known today for *To the Lighthouse* (1925) and *Mrs Dalloway* (1927).

Positioning

A Room of One's Own is only one text in Virginia Woolf's large and varied body of work. Woolf was prolific across several genres: in addition to nine novels published between 1915 and 1937, and *Between the Acts* published in 1941 after her suicide, she wrote short stories, essays, and book reviews. Her collected essays alone run to six volumes. Her reputation has continued to grow since her death, and she is considered to be one of the most significant writers of the twentieth century, a key figure in the histories of the novel, of modernism,* and of women's writing.

In her career before *A Room of One's Own*, Woolf had already distinguished herself as a novelist concerned with the fine detail of human experience, and the psychological effects of the world on the individual. *The Voyage Out* (1915) tells of a young woman on a journey to South America, and her intellectual awakening

❝ I am by no means confining you to fiction. If you would please me—and there are thousands like me—you would write books of travel and adventure, and research and scholarship, and history and biography, and criticism and philosophy and science. By so doing you will certainly profit the art of fiction. For books have a way of influencing each other. **❞**

Virginia Woolf, *A Room of One's Own*

through contact with other passengers on the boat. *Night and Day* (1919), which touches on the campaign for women's votes, linked the social challenges facing modern women to the idolizing of the past's "great men."

It is the novels of the 1920s, however, that remain Woolf's most widely recognized and studied: *Jacob's Room* (1922), *Mrs Dalloway* (1925), and *To the Lighthouse* (1927). All three explore the links and interactions between individual and collective experience, shaped by the characters' location in a nation, city, and family. In 1928, Woolf published *Orlando: A Biography*, which satirized traditional biography by presenting the life of a fantastical multi-gendered protagonist who lives for hundreds of years.

In *A Room of One's Own,* Woolf speaks with the critical authority of the established writer. The text explores feminist* themes she would examine again in later works such as the essay "Professions for Women" (1931) and *Three Guineas* (1938). Touching on themes central to her fiction and later critical texts, *A Room* is a key part of her output.

Integration

A Room of One's Own addresses issues through fiction, and through a narrative telling of lived experience. This is the most evident point it has in common with Woolf's other work. In her novels, particularly

from the 1920s onward, Woolf evolved a modernist stream-of-consciousness* technique, according to which the narrative voice is more fluid than earlier styles, such as the traditional omniscient narrator of many Victorian novels, and the reader is allowed to "see" the events of the novel from the perspective of a character or characters. In Woolf's work, characters' inner lives (their thoughts, emotions, memories) are vividly detailed as they experience external events, or interact with one another.

In trading the traditional voice of the lecturer—who, Woolf states, would provide "a nugget of pure truth"—for that of the fictive narrator, Woolf draws an important link between *A Room of One's Own* and her novels. The essay's readers are asked to interpret the text in the same way they might read *Mrs Dalloway* or *To the Lighthouse*: "Lies will flow from my lips," Woolf tells them, "but there may perhaps be some truth mixed up with them; it is for you to seek out this truth."[1] Readers are, in other words, encouraged to engage with the text actively, not as passive "listeners" at a lecture.

A Room of One's Own is also thematically consistent with Woolf's body of work as a whole. Critically, she would revisit feminism in the longer essay *Three Guineas* (1938), but she also addressed suffrage* and the women's movement* in general in her fiction, both before and after 1929. In *Night and Day* (1919), the character Mary Datchet is a suffrage activist, responsible for the paperwork, pamphlets, and discussion groups of a women's rights organization. In *The Years* (1937), Rose Pargiter is a "suffragette,"* involved with less peaceful activism for the vote.[2]

Significance

A Room of One's Own remains a significant work in at least two different areas. In Woolf studies, it is seen as the text that most clearly details Woolf's intellectual relationship to the issues at the heart of feminism. Though it makes use of fictional narrative techniques, it continues

to be read as a more direct statement than anything dealing with the women's movement found in her novels. But Woolf's reputation as one of English literature's most important figures does not rest on *A Room*. That role is filled by the landmark novels she produced. While *A Room* remains an important text for those trying to understand Woolf's views on feminism, and is often read as a means of placing her in context as an early twentieth-century female author, it is a minor work relative to her output as a whole.

However, this does not prevent *A Room of One's Own* from being a key text in literary and feminist history. In shifting emphasis from legal rights for women to broader social and psychological issues—above all the mental impact of patriarchy* on individual women—the essay anticipated the major developments in feminist thought in the second half of the twentieth century. While the women's movement of Woolf's lifetime (which has subsequently come to be known as first-wave feminism)* concentrated on gaining legal and political victories, the second-wave feminism* of the period after World War II* shifted focus to the kinds of psychological and cultural issues examined by Woolf's essay. Some critics have suggested that *A Room* has been co-opted to views that Woolf might not agree with. But there is no doubt that, as Laura Marcus observes, it is the text through which Woolf "was granted centre stage" in debates about feminism, women, and literature.[3]

NOTES

1 Virginia Woolf, *A Room of One's Own* and *Three Guineas*, ed. Anna Snaith (Oxford: Oxford University Press, 2015), 4.

2 For an extended examination of Woolf's relationship to the women's movement, see Sowon S. Park, "Suffrage and Virginia Woolf: 'The Mass Behind the Single Voice'," *Review of English Studies* 56, no. 223 (2005): 119–34.

3 Laura Marcus, *Virginia Woolf*, 2nd edn (Tavistock: Northcote House, 2004), 41.

SECTION 3
IMPACT

MODULE 9
THE FIRST RESPONSES

KEY POINTS

- On its publication, the main criticisms of *A Room of One's Own* were that its main point was disputable, and that Virginia Woolf's indirect writing style distracted from the central arguments.

- Woolf did not respond to her critics, though the more direct feminist* essay *Three Guineas* (1938) can be seen as a sequel to *A Room*.

- Since its original publication, Woolf's literary stature has encouraged readers to take the essay on its own terms, and it is now seen as a key moment in feminist literary history.

Criticism

On its publication in 1929, Virginia Woolf's *A Room of One's Own* received a relatively limited critical response. Before publication, Woolf herself was worried that the essay's combination of fiction and critical writing, along with its indirect approach to its central questions, would not "be taken seriously."[1] Expecting a condescending critical response from male reviewers, she thought she might be praised for her style and her "very feminine logic," and that they might recommend it as "a book to be put in the hands of girls."[2]

Reality was close to Woolf's predictions. An anonymous review in the important literary paper the *Times Literary Supplement* praised the essay as "delightfully peripatetic," meaning that it wandered in subject matter, "spirited and goodtempered [*sic*]."[3] The prominent literary critic and novelist Arnold Bennett* was similarly condescending. While praising Woolf's style—"she can write"—he said the

> **❝**I shall get no criticism, except of the evasive jocular kind ... the press will be kind and talk of its charm and sprightliness; also I shall be attacked for a feminist and hinted at for a Sapphist ... I shall get a good many letters from young women. I am afraid it will not be taken seriously. Mrs. Woolf is so accomplished a writer that all she says makes easy reading.**❞**
>
> Virginia Woolf, *A Writer's Diary*

indirectness of the essay was accidental. Woolf could not stick to her point because she was a "victim of her extraordinary gift of fancy."[4] The essay's "thesis"—that one must have £500 a year and a room with a lock on the door to write fiction—was "disputable," however.[5] To prove that, he offered himself and the Russian novelist Fyodor Dostoyevsky* as examples of writers with neither money nor room, ignoring the text's broader questions about women.

Despite this, *A Room of One's Own* was critically praised. One contemporary critic anticipated later feminist readings of the essay by stating that "Woolf's attitude is far from the polemics of traditional feminism. From the ashes of those bitter conflicts has risen a new conception of the whole problem, to which Mrs Woolf gives a form and a voice."[6] That form and voice would go on to define later feminist readings of the essay.

Responses

Though Woolf was partially correct in her predictions of patronizing reviews, above all by Arnold Bennett, *A Room of One's Own* sold extremely well. It was, in fact, Woolf's biggest-selling book to date, and its sales helped cement her financial independence as well as her literary reputation.[7] After publication,

Woolf did not respond to the critics or engage in dialogue with them. She let the book make its own arguments.

In a sense, however, Woolf had already responded to possible negative criticism before the essay's publication. The drafts of the book show how sensitive Woolf was to potential criticism, to her audience, and to how her writing might reflect on herself. Adapting the lectures upon which it was originally based, she toned down some harsh claims, removed negative references to particular authors, and created an alter ego (another version of herself) to be the narrator for her text. She was, as the author and literature scholar Susan Gubar* notes, "worried about sounding strident," and about being "rejected as either a feminist or a lesbian," and took steps to ensure this would not be the case.[8] These alterations give the essay its elusive and playful indirectness, and also a great deal of its richness.

Later responses have tended to praise *A Room* precisely *for* its feminism and its lesbian subtext, and its elusiveness has only helped broaden the number of interpretations that seem valid. As Gubar states, it is now "a classic—if not *the* touchstone text—in the history of feminism," heavily anticipating the psychological, social, economic, and ideological concerns at the center of second-wave feminism.*[9]

Conflict and Consensus

A Room of One's Own remains a text that generates a great deal of debate within Woolf studies, feminist literary theory, and feminism more generally. Though it is accepted as "undoubtedly Woolf's most important contribution to literary criticism and theory," and a key text in the history of feminist thought, debates still continue over precisely what Woolf intended to say, and over whether or not that might provide a model for thought in a contemporary context.[10] As Laura Marcus notes: "It is striking that Woolf has been used by so many different critics to exemplify one or another of a variety of incommensurate positions and that such weight has been attached

to establishing her commitment to whichever position she is held to represent."[11]

Woolf returned to her own views on feminist issues in her 1938 work *Three Guineas,* initially conceived as a sequel to *A Room of One's Own.* Published a decade after the earlier essay, *Three Guineas* again examines the distance between women's apparent legal rights and what their material conditions actually allow them to achieve. The focus this time, however, shifts away from creative expression and art toward political agency (freedom). *A Room of One's Own* criticized the psychological effects of patriarchy* on women. Returning to that theme, *Three Guineas* more directly emphasizes the need for women to have visible, active, equal roles in society. Close to the outbreak of World War II,* *Three Guineas* also makes a direct link between patriarchy and wasteful conflict—a stronger direct political message than anything to be found in *A Room.*

Despite the more precise tone of *Three Guineas,* however, *A Room of One's Own* remains the key text for considering Woolf's views on and contribution to feminism. As such, it continues to be a subject of debate and of reappropriation by new generations of feminist thinkers.

NOTES

1 Virginia Woolf, *A Writer's Diary,* ed. Leonard Woolf (London: Harcourt, 1954), 148.

2 Woolf, *Writer's Diary,* 148.

3 See Robin Majumdar and Allen McLaurin, eds., *Virginia Woolf: The Critical Heritage* (London: Routledge & Kegan Paul, 1975), 255, 256.

4 Majumdar and McLaurin, eds., *Virginia Woolf: The Critical Heritage,* 258, 259.

5 Majumdar and McLaurin, eds., *Virginia Woolf: The Critical Heritage,* 259.

6 Majumdar and McLaurin, eds., *Virginia Woolf: The Critical Heritage,* 260.

7 Hermione Lee, *Virginia Woolf* (London: Vintage 1997), 557.

8 See Susan Gubar, "Introduction," in Virginia Woolf, *A Room of One's Own,*
 ed. Susan Gubar (Orlando: Harcourt, 2005), xxxvii. See also Virginia
 Woolf, *Women & Fiction: The Manuscript Versions of A Room of One's
 Own*, ed. S. P. Rosenbaum (Oxford: Blackwell, 1992).

9 Gubar, "Introduction," xxxvi.

10 Jane Goldman, *The Cambridge Introduction to Virginia Woolf* (Cambridge:
 Cambridge University Press, 2006), 97.

11 Laura Marcus, *Virginia Woolf*, 2nd edn (Tavistock: Northcote House,
 2004), 41.

MODULE 10
THE EVOLVING DEBATE

KEY POINTS

- With the rise of second-wave feminism* in the postwar* period, a movement that addressed the wider civic and cultural status of women, Virginia Woolf's central argument that the material conditions of life have a huge effect on women's ability to produce art was widely accepted.

- Though second-wave feminism had many influences, *A Room of One's Own* can be seen as an important precursor to many of its ideas and debates.

- Woolf's arguments in the essay have been applied in new contexts in recent years, proving that it has relevance to areas Woolf herself did not foresee.

Uses and Problems

Virginia Woolf's *A Room of One's Own* has a presence in feminist* literary theory that is both controversial and influential. The period after World War II* saw the emergence of what has come to be known as second-wave feminism. In contrast to the first-wave feminism* of Woolf's own time, which concentrated on the winning of legal rights and entry into university and the professions, second-wave feminism had broader concerns that had much in common with Woolf's arguments and questions in *A Room*.

Among the concerns of second-wave feminism, the widespread and negative influence of patriarchy* is central. Woolf's vivid characterization in *A Room of One's Own* of England's top-to-bottom privileging of men, and locking out of women, was bound to strike a chord. So too, as French feminism in particular became increasingly

> **❝** It is not of course surprising that many male critics have found Woolf a frivolous Bohemian* and negligible Bloomsbury* aesthete, but the rejection of this great feminist writer by so many of her Anglo-American feminist daughters requires further explanation. **❞**
>
> Toril Moi, *Sexual/Textual Politics*

concerned with society as a "textual"* (i.e. readable) set of symbols and languages, was Woolf's concern with feminine traditions and textuality. In particular, the statement in *A Room* that "it would be a thousand pities if women wrote like men" (though contradicted later in the essay),[1] anticipated one of the major themes of 1970s and 1980s feminist theory—Hélène Cixous's* *écriture féminine*, or "feminine writing."[2]

At the same time, however, changes and developments in feminist thought provided a critique of *A Room of One's Own*, most notably from the American feminist literary critic Elaine Showalter.* Showalter framed her *A Literature of Their Own* (1977) as a long response to what she saw as Woolf's shortcomings. It would not be until the 1980s that influential figures such as the Norwegian literary theorist Toril Moi* would restore Woolf's reputation.

Schools of Thought

As the feminist literary scholar Jane Goldman notes, in the 1970s *A Room of One's Own* became a recurrent point of reference in debates on the theoretical aspects of feminism. In particular, the essay's cultural materialist* take on women's suppression—examining it through the effects of everyday life and economic circumstances—was taken on by Marxist* feminists who, having identified the ways in which women are oppressed by the workings of the social

and economic system of capitalism, saw it as powerful proof of the relevance of Marxist theory to women's situations.[3] Such readings were confirmed within Woolf studies by Jane Marcus's *Art and Anger: Reading Like a Woman* (1988) and *Virginia Woolf and the Languages of Patriarchy* (1987).

As Showalter's *A Literature of Their Own* showed, however, it was also possible for feminists to disagree with Woolf, even to the point of attacking her as unfeminist. For Showalter, by questioning whether or not a specifically "female" way of writing is a worthy goal, Woolf is guilty of a "flight into androgyny"—of seeking to not be a woman, and therefore not be a feminist either.[4] Rather than paving the way for the liberation of authentic female voices, *A Room of One's Own* is, for Showalter, a text that leads women into "the sphere of exile and the eunuch"—a place outside of society, where they will be deprived of their sex.[5]

While Showalter's critique struck a chord with feminists wanting to define a specifically female identity through history, it soon came under attack. It was definitively countered by influential theorist Toril Moi—who promotes a more flexible conception of "woman" and women's voices in her work—in her 1985 book *Textual/Sexual Politics*. As Moi suggested, with some tact, if feminist theorists could not find a way of using "the work of the greatest British woman writer of [the twentieth] century," then "the fault may lie with their own critical and theoretical perspectives."[6]

In Current Scholarship

A Room of One's Own remains a key text in Woolf studies, and a seminal work in the history of literary theory and feminism. This does not mean, however, that a simple consensus has been reached about its meaning. Woolf's strategy of speaking through a narrator, and of withholding commitment to any clear "message" beyond the need for women to have money and privacy, has left the essay

open to many different interpretations—often contradictory. As the author and scholar Susan Gubar* notes, critics have at different times labeled it as both feminist and antifeminist*—"too angry in [its] caricaturing of men" and "fearful of rage"; "quasi-Marxist" and "elitist."[7] Such contradictions show the place of *A Room* in many critical debates, all of which stem from its complex and challenging prose, as well as differing attitudes toward its author and the context of its creation.

Toril Moi's restoration of Woolf within feminist literary theory left open a path for other feminist theorists to follow, ensuring a place for *A Room of One's Own* in literary and feminist studies ever since. Two books in particular continue to mark the field: the literary studies professor Makiko Minow-Pinkney's *Virginia Woolf and the Problem of the Subject* (1987), and the English Literature professor Rachel Bowlby's* *Virginia Woolf: Feminist Destinations* (1988; republished with five further essays in 1997).[8] The former brought Woolf together with French feminist theory; the latter uses psychoanalytical* readings of Woolf's feminism to make a case for her work's open and shifting meanings.

Since the 1990s, with the rise of lesbian feminist perspectives and queer* theory in literary studies, *A Room of One's Own* continues to be read and discussed, perhaps more than ever before. Recent readings of the essay, and of Woolf's work more generally, have been marked by sustained examinations of her fluid sexuality, with Eileen Barrett and Patricia Cramer's collection *Virginia Woolf: Lesbian Readings* (1997) remaining influential.

NOTES

1 Virginia Woolf, *A Room of One's Own* and *Three Guineas*, Anna Snaith (Oxford: Oxford University Press, 2015), 66.

2 See Hélène Cixous, "The Laugh of the Medusa," trans. Keith and Paula Cohen, *Signs* 1, no. 4 (1976): 875–93.

3 Jane Goldman, *The Cambridge Introduction to Virginia Woolf* (Cambridge: Cambridge University Press, 2006), 130. See also Virginia Woolf, *Women and Writing,* ed. Michèle Barrett (London: Women's Press, 1979).

4 Elaine Showalter, *A Literature of Their Own: From Charlotte Brontë to Doris Lessing* (Princeton: Princeton University Press, 1999), 263.

5 Showalter, *A Literature of Their Own*, 285.

6 Toril Moi, *Textual/Sexual Politics: Feminist Literary Theory*, 2nd edn (London: Routledge, 2002), 9

7 Woolf, *A Room of One's Own*, lviii.

8 Makiko Minow-Pinkney, *Virginia Woolf and the Problem of the Subject* (Edinburgh: Edinburgh University Press, 2010); Rachel Bowlby, *Feminist Destinations and Further Essays on Virginia Woolf* (Oxford: Blackwell, 1997).

MODULE 11
IMPACT AND INFLUENCE TODAY

KEY POINTS

- *A Room of One's Own* remains an essential text in Woolf studies and in the history of feminism.*

- It is a persuasive work on the deep consequences of daily social exclusion and material disadvantage, challenging readers to consider their own lived experience in regard to feminism.

- Its suggestive questioning of the role of social and material conditions in shaping women's lives and creative work remains relevant today, even if social and material conditions have changed considerably.

Position

There can be no doubt that Virginia Woolf's *A Room of One's Own* remains a key text for students of literature. Woolf's position as, in the literary theorist Toril Moi's* words, "the greatest British woman writer of [the twentieth] century" has helped maintain the essay's place in the literary canon.* It is a seminal text in the development of Woolf's own career, in British modernism,* and in feminist literary theory. Even where theorists, such as the influential feminist scholar Elaine Showalter,* have disagreed with Woolf's approach and suggestions, the essay is a landmark in the history of women's literature.

A crucial element in *A Room*'s continuing presence in critical debate is its rich and complex nature. An open-ended text beyond its deceptively simple thesis, it continues to draw scholarly exploration and revisions. Both formally and in terms of its themes, it also remains influential. The American feminist literary critic Susan Gubar's*

❝Of course criticism has taken many a narrative turn before, though it was obviously Virginia Woolf's *A Room of One's Own* and (to a lesser extent) her *Three Guineas* that inspired my efforts.❞

Susan Gubar, *Rooms of Our Own*

Rooms of Our Own (2006) is only one of a number of contemporary critical texts that either make direct references to Woolf's essay or take stylistic and intellectual inspiration from Woolf's original.[1] Within literary and feminist studies, Woolf remains a crucial figure, and, though *A Room* is only a single slim essay among her prolific output, it remains one of her most important works.

Outside of academia, *A Room of One's Own* continues to make an impact. Among those influenced is the Nobel Prize-winning South African novelist J. M. Coetzee,* whose 2003 novel *Elizabeth Costello* takes its central inspiration from *A Room*'s innovative hybrid form, following a female novelist as she delivers a series of fictionalized lectures in various contexts.

Interaction

Susan Gubar's *Rooms of Our Own* shows the strong influence of both Woolf and the essay among feminist literary critics. Gubar identifies Woolf as central to her work, and in *Rooms of Our Own* she explores that influence with the same hybrid mixture of fiction and critical writing that Woolf uses in her essay. The book traces a year in the life of an English professor at an American university, taking direct inspiration from *A Room of One's Own*, with Gubar christening her narrator Mary Beton, as Woolf does hers.

Rooms of Our Own is a meditation on both female experience in the present day and on issues that have become central to feminism since Woolf's time: "the disentangling of gender from sex,

of social roles from biological genitalia, of masculinity from males and femininity from females."[2] Placing this list in the distinctively Woolfean mouth of her own narrator, Gubar shows just how much feminism has changed since Woolf's time, and how relevant Woolf's approach might still be.

J. M. Coetzee is less explicit about his debt to Woolf. *Elizabeth Costello* takes as its main character an aging Australian novelist and follows her as she gives lectures on a range of topics, including animal rights. Early in the novel, the reader learns that Woolf is an influential figure in Costello's life and, like Woolf, she is pressured to give her thoughts on a range of "big questions," including "the woman question."[3] Woolf's influence is even more obvious in the actual creation of the novel: it does not just portray lectures, but actually consists of them. "Elizabeth Costello" was a persona adopted by Coetzee to deliver lectures in real life, just as Woolf adopted "Mary Beton."

The Continuing Debate

As Elaine Showalter's criticism suggests, *A Room of One's Own* is as controversial for its methodology as for its findings. Toril Moi notes that Showalter and others want *A Room* to give "a firm perspective from which to judge the world." But the essay remains hard to pin down behind its narrator, its humor, and its irony.[4] That method remains controversial, running counter to the accepted conventions of political and academic writing.

Similar critiques were aimed at Coetzee's *Elizabeth Costello*, which started life as pieces written for the Tanner Lectures (on philosophy and ethics) at Princeton University in 1997–98. Rather than give conventional lectures, Coetzee read two stories about a female novelist giving lectures. Originally published with responses from four philosophers as *The Lives of the Animals* (1999), the pieces caused controversy. As the novelist and critic David Lodge* noted

in his review of *Elizabeth Costello*, the respondents felt "stymied" by the "veils of fiction behind which [Coetzee] had concealed his own position."[5] As James Wood put it, Coetzee was accused by the philosopher Peter Singer* of "evasion."[6] Like Woolf, whose influence is clear in *Elizabeth Costello*'s central device, critics wanted Coetzee to speak without resorting to fiction.

Susan Gubar anticipated similar critiques of her use of "narrative criticism" in *Rooms of Our Own*. Readers might say that no "new advance in knowledge can be made without … footnotes and judicious specificity … careful reasoning and historical archiving."[7] She suggests, though, that Woolf's method remains useful, and necessary "when multiple perspectives, contradictory convictions, more concrete approaches to interconnected cultural problems have to be broached."[8] As she says, Woolf's investigative techniques remain contentious, but might be vital in grappling with the issues that continue to confront us today.

NOTES

1 See Susan Gubar, *Rooms of Our Own* (Champaign: University of Illinois Press, 2006).

2 Gubar, *Rooms of Our Own*, 2.

3 J. M. Coetzee, *Elizabeth Costello* (London: Vintage, 2004), 10.

4 Toril Moi, *Textual/Sexual Politics*, 2nd edn (London: Routledge, 2002), 9.

5 David Lodge, "Disturbing the Peace: *Elizabeth Costello* by J. M. Coetzee," *New York Review of Books,* November 20, 2003, accessed September 21, 2015, http://www.nybooks.com/articles/archives/2003/nov/20/disturbing-the-peace/

6 James Wood, "A Frog's Life: *Elizabeth Costello: Eight Lessons* by J. M. Coetzee," *London Review of Books* 25, no. 20 (October 23, 2003), 15.

7 Gubar, *Rooms of Our Own*, 217.

8 Gubar, *Rooms of Our Own*, 218.

MODULE 12
WHERE NEXT?

KEY POINTS

- Given Virginia Woolf's place in the literary canon,* and the continuing relevance of its issues today, *A Room of One's Own* looks set to remain an important text.

- In the future the essay will continue to engage new readers and influence critics, writers, and feminist* thinkers today.

- *A Room* remains a seminal text, and a crucial document in the history of feminism and literary theory.

Potential

It seems indisputable that Virginia Woolf's *A Room of One's Own* will continue to have a place in literary studies and feminism. Despite the huge advances in women's rights and social freedoms since 1928, Woolf's analysis of the ways in which social convention and economic conditions force women into certain roles and constrain them physically, psychologically, and creatively remains powerful and influential. As the work of the literary critic Susan Gubar* and the novelist J. M. Coetzee* shows, the essay's influence continues to be felt today, providing ways of examining feminist issues and other ethical problems that are still unconventional.

One factor ensuring the place of *A Room of One's Own* in the canon of key texts in feminist history is Woolf's influence as a novelist. Woolf is a fixture of literature syllabuses across the English-speaking world. She is regarded as a groundbreaking innovator in fiction and a crucial figure in the history of literature. *A Room* is the most direct of Woolf's texts to address the conditions of writing as a woman in the

> **❝**[The] opportunity will come, and the dead poet who was Shakespeare's sister will put on the body which she has so often laid down. Drawing her life from the lives of the unknown who were her forerunners, as her brother did before her, she will be born. **❞**
>
> Virginia Woolf, *A Room of One's Own*

early twentieth century. It is a vital document in understanding her development. More broadly, however, it remains a powerful text for understanding and analyzing the ways in which the everyday, material conditions of life affect writers' minds—whether or not they are the female writers Woolf intended to examine.

Though necessarily limited in its own historical perspective, and bound up with certain standard assumptions of an age and place in which class and racial oppression were the norm, *A Room of One's Own* appears likely to continue providing inspiration in a number of fields. Feminism has developed in ways that Woolf could never have imagined. It is an ever more theoretically complex field, linked to gender studies, queer theory,* and postcolonial theory* (the theoretical inquiry into the various legacies of colonialism). But Woolf's essay remains a touchstone.

Future Directions

It is hard to predict the directions critics of *A Room of One's Own* will take in the future. Clearly, though, as consideration of the limits of Woolf's "room" continues, and efforts to resurrect writers obscured by circumstance or hegemony (political or cultural domination) persist, this text will contribute to future intellectual work. *A Room* is enduringly valuable for its insistence that women's lives should not be confined to domestic realms, and that creative

or professional pursuits, as well as independent lifestyles, are both possible and acceptable.

It is true that in many countries today, the disparities between women's and men's opportunities and economic conditions have shrunk. Nowadays, British women are able to pursue education, careers, and creative endeavors without facing the barriers met by Woolf and her first readers. However, disparity persists between men and women and between other dominant and minority social groups in these realms. Cultural expectations of women's domestic obligations and inclinations also remain in flux. From a global perspective, women's educational, professional, and artistic opportunities are still far more narrowly constrained than those of men. While *A Room of One's Own* maintains its relevance it is sure to encourage current and future debate on these topics.

As the American novelist Alice Walker's* application of Woolf's framework to the experience of black women in American history shows, Woolf's ideas are not restricted to her original audience.[1] By making a link between material conditions and creative efforts, *A Room of One's Own* offers a valuable example for debate over the means necessary for artistic production. It can also be used to argue for the rights of all citizens to earn those means—whether they be women or members of any other group disadvantaged by prevailing social conditions.

Summary
Today, anyone with an interest in the development of the novel, in women's writing, or in feminism should read *A Room of One's Own* as a text that is both historically important and of continuing relevance. The essay deserves special attention because of its unique blend of literary and critical modes, its powerful and practical argument for women's rights, its place in Virginia Woolf's wider work, and its lasting textual strength. Woolf's works enjoy a prominent place in the literary

canon today, studied by scholars around the world. Her work in modernist* fiction as well as her critical engagements with literary genres, modern aesthetics, and social issues have made her a unique presence in Anglophone literature. *A Room* is evidence of that status and of the kinds of challenges Woolf faced in achieving her goals.

The essay has a specific historical context, and there are limitations to Woolf's perspective. But these very limitations have prompted further critical engagement, underscoring the text's foundational importance. Critics such as Alice Walker have pointed out that the essay's central argument cannot speak for all women or all would-be writers across history. But they have also worked to expand Woolf's room so that it might be available to more identities and other voices. That this was Woolf's hope for her text's legacy can hardly be questioned.

In discussing the seminal status and sophistication of *A Room of One's Own* we must not forget its readability. It is not just an important essay: it is also an engaging, involving, and persuasive text that stands on its own, as well as forming a perfect introduction to Woolf's work and to feminist literary theory.

NOTES

1 See Alice Walker, *In Search of Our Mothers' Gardens: Womanist Prose* (London: Phoenix, 2005).

GLOSSARIES

GLOSSARY OF TERMS

Antifeminism: an umbrella term for ideological opposition to feminism.

Androgyny: a term for a combination of masculine and feminine characteristics, whether biological or psychological.

Bloomsbury Group: an influential set of English writers, artists, philosophers, and intellectuals—including Virginia Woolf, John Maynard Keynes, and E. M. Forster—who formed a loose collective in and around Bloomsbury Square in London.

Bohemian: a term for socially unconventional people, particularly writers, intellectuals, artists, and actors, often espousing antiestablishment or politically radical views.

Cultural materialism: a critical movement that analyzes works of art through the material conditions of their production. Though often credited to the postwar British literary critic Raymond Williams, its roots can be traced back to the work of the German economist and political philosopher Karl Marx (1818–83).

Elizabethan era: a period of English history and culture covered by the reign of Queen Elizabeth I in the years 1558–1603.

Feminism: a set of movements and ideologies seeking to achieve equality for women.

First-wave feminism: a late nineteenth- and early twentieth-century women's movement, active principally in Britain and North America, which sought equal legal standing with men, particularly the right to vote.

Girton College: one of the constituent colleges of the University of Cambridge; established in 1869, it was a female-only college until 1976 when they voted to admit men.

Hogarth Press: a publishing imprint started in 1917 by Virginia and Leonard Woolf at their home, Hogarth House, in Richmond. Together with Woolf's own writing, it is notable for publishing the first book edition of T. S. Eliot's *The Waste Land*.

Literary canon: a term for the set of literary works across history that have traditionally been accepted as the most influential and worthy of study by scholars and academics.

Misogyny: the hatred of women.

Modernism: a broad movement in the arts characterized both by a break with traditional formal constraints and a heavy investment in artistic traditions and lineage. In literature, landmark figures were Virginia Woolf, T. S. Eliot, and James Joyce, all of whom produced groundbreaking works in the first third of the twentieth century.

Newnham College: one of the constituent colleges of the University of Cambridge; founded as a women's college in 1871, it remains female-only to this day.

Patriarchy: a term for a social system in which men hold the primary power, social privileges, and authority. In feminist theory, Western society is seen as pervasively patriarchal.

Postcolonial theory: a broad category of critical and philosophical work dealing with the cultural and intellectual legacies of colonialism and imperialism in former colonies of Western nations, including Britain, France, and Spain.

Postwar period: the period immediately following World War II in Europe and America.

Psychoanalysis: a set of theories for treating psychological illness, first elaborated by Austrian physician Sigmund Freud at the end of the nineteenth century.

Queer theory: a broad field of theory associated with literary studies, women's studies, and cultural studies that is concerned with inquiry into supposedly deviant sexual identities.

Second-wave feminism: feminism of the postwar era often strongly influenced by French feminist theory and focused on issues such as women's sexual freedom, workplace equality, and reproductive rights.

Stream of consciousness: a term for a narrative technique that mimics the thinking processes of a character, directly portraying their perceptions of narrative events through their thoughts.

Suffrage: the right to vote in public elections; often refers specifically to the women's suffrage movement of first-wave feminism.

Suffragette: a term for female members of the women's movement's campaign for women's voting rights (suffrage) in the nineteenth and early twentieth centuries; it was particularly reserved for more militant campaigners.

Textual: literally, like or relating to a text; often used metaphorically to describe society in philosophy, sociology, and literary theory to suggest that social structures can be "read" like a book or text.

University of Cambridge: the second university founded in England, in 1209; composed of 31 colleges, it is widely regarded as one of the world's most prestigious universities.

Women's movement: an umbrella term for the women's liberation or feminist movement. It is also often applied specifically to early feminism and the movement for women's suffrage.

World War I: a global conflict from 1914 to 1918 that centered on clashes in Europe between Germany–Austria–Hungary, the "Central Powers," and the Allies—Britain, France, and Russia.

World War II: the global war of 1939–45 involving over 30 countries in a conflict over the expansionist policies of Nazi Germany and its allies.

PEOPLE MENTIONED IN THE TEXT

Jane Austen (1775–1817) was an English novelist renowned for her closely observed satirical fiction based on the society of her day. These works are among the most celebrated in the English literary canon, and include *Pride and Prejudice* (1813) and *Emma* (1815).

Aphra Behn (circa 1640–89) was an English playwright and poet. The first major female writer in English drama, she was among the earliest professional female writers; her best-known works today are the play *The Rover* (in two parts, 1677 and 1681) and the prose fiction *Oroonoko* (1688).

Clive Bell (1881–1964) was an English art critic and author who advocated the significance of form over subject matter in art. A member of the Bloomsbury Group, he was married to Virginia Woolf's sister, Vanessa.

Vanessa Bell (née Stephen; 1879–1961) was an English painter, illustrator, and designer; Virginia Woolf's sister, she was a member of the Bloomsbury Group and wife of Clive Bell.

Arnold Bennett (1867–1931) was an English novelist, journalist, and critic. A prolific writer, he remains perhaps best known for his 1908 novel *The Old Wives' Tale*.

Rachel Bowlby is a professor of English literature at Princeton University; she is best known for her influential 1988 study *Virginia Woolf: Feminist Destinations*.

Brontë sisters were influential English female novelists of the early nineteenth century. **Charlotte (1816–55)**, the most prolific, is best remembered for *Jane Eyre* (1847); **Emily (1818–48)** wrote only one novel, *Wuthering Heights* (1847); **Anne (1820–49)** wrote two, *Agnes Grey* (1847) and *The Tenant of Wildfell Hall* (1848).

Hélène Cixous (b. 1937) is an influential French feminist writer and philosopher, considered one of the mothers of poststructuralist feminist theory. She is widely known for her 1975 article "The Laugh of the Medusa," and her elaboration of the idea of *écriture féminine* ("feminine writing").

Edward Clarke (1820–77) was a medical doctor and professor of medicine at Harvard University. He is remembered today for his misguided stance on women's education in his *Sex in Education; or, A Fair Chance for Girls* (1873).

J. M. Coetzee (b. 1940) is a Nobel Prize-winning South African novelist, essayist, and translator. The author of 12 novels and 4 volumes of fictionalized autobiography, he is widely considered to be one of the world's most important living novelists.

Fyodor Dostoevsky (1821–81) was a Russian novelist, regarded as one of the most important writers of the nineteenth century; his most famous works are *Crime and Punishment* (1866) and *The Brothers Karamazov* (1880).

George Eliot (1819–80) was the pen name of the novelist Mary Ann Evans. Widely considered one of the most important writers in the history of the novel, her best-known works include *The Mill on the Floss* (1860) and *Middlemarch* (1872).

T. S. Eliot (1888–1965) was an American-born poet and critic who was at the forefront of British modernism. His most famous works include the long poems *The Waste Land* (1922) and *Four Quartets* (1945), and the seminal critical essay "Tradition and the Individual Talent" (1919).

E. M. Forster (1879–1970) was an English novelist, essayist, literary critic, and Bloomsbury Group member. His fiction includes *A Passage to India* (1908), *Howard's End* (1910), and the homosexually themed *Maurice* (1971), which was written in 1913–14 but not published until after his death.

Roger Fry (1866–1934) was an English painter and art critic. A member of the Bloomsbury Group, he is known for christening the genre of postimpressionist painting.

Margaret Fuller (1810–50) was an American journalist and early feminist; her book *Woman in the Nineteenth Century* (1843) is considered perhaps the first American feminist work.

Charlotte Perkins Gilman (1860–1935) was a prominent American feminist and writer; her book *Women and Economics: A Study of the Economic Relation Between Men and Women as a Factor in Social Evolution* (1898) is a seminal text in the history of feminism.

Susan Gubar (b. 1944) is an American author, feminist literary critic, and professor of English and women's studies at Indiana University. She is best known today for coauthoring (with Sandra M. Gilbert) *The Madwoman in the Attic: The Woman Writer and the Nineteenth-Century Literary Imagination* (1979).

Cicely Hamilton (1872–1952) was an English actress, writer, and feminist; she was the co-founder of the Women Writers' Suffrage League in 1908.

James Joyce (1882–1941) was an Irish novelist and pioneering member of the modernist movement. He is best known for his novels *Ulysses* (1922) and *Finnegan's Wake* (1939).

John Maynard Keynes (1883–1946) was an influential English economist whose work in macroeconomics revolutionized the discipline.

D. H. Lawrence (1885–1930) was an English novelist, poet, and critic whose controversial novel *Lady Chatterley's Lover* (1928) is considered a landmark in the development of the novel.

David Lodge (b. 1935) is an English novelist and critic known for his satirical novels about academic life and for his literary criticism, particularly the essays collected in *The Art of Fiction* (1992).

Toril Moi (b. 1953) is a Norwegian-born feminist theorist and literary critic. Currently James B. Duke professor of literature and romance studies and professor of English, philosophy, and theatre studies at Duke University, she is best known for *Sexual/Textual Politics: Feminist Literary Theory* (1985) and *What is a Woman? And Other Essays* (1999).

Ezra Pound (1885–1972) was an American poet whose work helped found the modernist movement; he is best known for his complex, allusive epic poem sequence *The Cantos* (1917–69).

Arthur Quiller-Couch (1863–1944) was an English writer and literary critic. Though prolific in several genres, he is now best remembered for editing *The Oxford Book of English Verse 1250–1900* (1900).

Eleanor Rathbone (1872–1946) was an English feminist and independent Member of Parliament. She was a prominent and long-term campaigner for women's rights in Britain.

Elizabeth Robins (1862–1952) was an American actress, playwright, and suffragette. After moving to England in 1888, she became involved in the women's movement, writing the influential suffrage play *Votes for Women!* (1907).

Vita Sackville-West (1892–1962) was a poet, novelist, and journalist, also known as an important garden designer. Famous for having a number of extramarital affairs with women, she had a relationship with Virginia Woolf, and inspired Woolf's novel *Orlando: A Biography*.

Sappho (circa 630–570 B.C.E.) was a noted Greek lyric poet, born on the island of Lesbos. Though only fragments of her work survive today, she is famous for her love poetry addressed to both women and men; indeed, her name was almost synonymous with lesbianism until the mid-twentieth century.

Olive Schreiner (1855–1920) was a South African author, antiwar campaigner, and early feminist. Today she is best known for her novel *The Story of an African Farm* (1883) and the feminist work *Women and Labour* (1911).

William Shakespeare (1564–1616) was an English poet and playwright, the author of 154 sonnets and 38 plays, many of which are core works in the study of English literature, as well as living texts, constantly kept alive in performance throughout the world. He is known as England's national poet.

Elaine Showalter (b. 1941) is an American feminist literary critic known for developing "gynocriticsm"; her best-known works are *Towards a Feminist Poetics* (1979) and *Inventing Herself: Claiming a Feminist Literary Heritage* (2001).

Peter Singer (b. 1946) is an Australian moral philosopher and professor of bioethics at Princeton University; he is best known for his 1975 work *Animal Liberation*, regarded as a classic work on animal rights.

Adrian Stephen (1883–1948) was the younger brother of Virginia Woolf and a member of the Bloomsbury Group. A pioneering adopter of Sigmund Freud's theories, he was among the first British psychoanalysts.

Leslie Stephen (1832–1904) was an English author, critic, and biographer. The father of Virginia Woolf, he is best known today as the founding editor of the *Dictionary of National Biography*.

Thoby Stephen (1880–1906) was the older brother of Virginia Woolf; he is often credited with starting the Bloomsbury Group's gatherings.

Lytton Strachey (1880–1932) was an English biographer and member of the Bloomsbury Group. Today he is best known for his 1918 biographical work *Eminent Victorians*.

Ray Strachey (née Costelloe; 1887–1940) was an English feminist politician and writer. Wife of Lytton Strachey's elder brother, Oliver, she is best known today for her role in the suffrage movement and her 1928 book *The Cause: A Short History of the Women's Movement in Great Britain*.

Alice Walker (b. 1944) is an American author, feminist, and activist known for her 1982 novel *The Color Purple* and her 1983 essay collection *In Search of Our Mothers' Gardens: Womanist Prose*.

Otto Weininger (1880–1903) was an Austrian philosopher whose misogynist work *Sex and Character* (1903) rose to international prominence after his suicide.

Phillis Wheatley (1753–84) was an African American poet and the first African American woman to be published. Sold into slavery in America as a child, her *Poems on Various Subjects, Religious and Moral* (1773) brought her fame and eventually freedom.

Mary Wollstonecraft (1759–97) was an English writer and philosopher, best known for her groundbreaking feminist tract *A Vindication of the Rights of Woman* (1792).

Leonard Woolf (1880–1969) was Virginia Woolf's husband from 1912 until her death in 1941. A member of the Bloomsbury Group, he was a noted publisher and author, co-founding the Hogarth Press with his wife and composing a number of works on political theory.

WORKS CITED

WORKS CITED

Antor, Heinz. *The Bloomsbury Group: Its Philosophy, Aesthetics, and Literary Achievement*. Heidelberg: C. Winter, 1986.

Barrett, Eileen, and Patricia Cramer, eds. *Virginia Woolf: Lesbian Readings*. New York: New York University Press, 1997.

Bennett, Arnold. "Queen of the High-Brows" (review of *A Room of One's Own*, *Evening Standard*, November 28, 1929). In *Virginia Woolf: The Critical Heritage*, edited by Robin Majumdar and Allen McLaurin. London: Routledge & Kegan Paul, 1975.

Bowlby, Rachel. *Feminist Destinations and Further Essays on Virginia Woolf*. Oxford: Blackwell, 1997.

Briggs, Julia. *Virginia Woolf: An Inner Life*. Orlando: Harcourt, 2005.

Cixous, Hélène. "The Laugh of the Medusa." Translated by Keith and Paula Cohen. *Signs* 1, no. 4 (1976): 875–93.

Clarke, Edward H. *Sex in Education; or, A Fair Chance for Girls* (1873). In Nancy F. Cott, *Root of Bitterness: Documents of the Social History of American Women*. Lebanon, NH: University Press of New England, 1996.

Coetzee, J. M. *Elizabeth Costello*. London: Vintage, 2004.

Eliot, T. S. "Tradition and the Individual Talent." In *Selected Essays*. London: Faber & Faber, 1951.

Fuller, Margaret. *Woman in the Nineteenth Century*. Edited by Arthur B. Fuller. New York: W. W. Norton, 1971.

Gilman, Charlotte Perkins. *The Man-Made World: Or, Our Androcentric Culture*. New York: Charlton, 1911.

Goldman, Jane. *The Cambridge Introduction to Virginia Woolf*. Cambridge: Cambridge University Press, 2006.

Gubar, Susan. "Introduction." In Virginia Woolf, *A Room of One's Own*, edited by Susan Gubar. Orlando: Harcourt, 2005.

———. *Rooms of Our Own*. Champaign: University of Illinois Press, 2006.

Hamilton, Cicely. *Marriage as a Trade*. New York: Moffat, Yard and Co., 1909.

Keegan, John. *The First World War*. New York: Vintage, 2000.

Lee, Hermione. *Virginia Woolf*. London: Vintage, 1997.

Lodge, David. "Disturbing the Peace: *Elizabeth Costello* by J. M. Coetzee." *New York Review of Books*, November 20, 2003. Accessed September 21, 2015. http://www.nybooks.com/articles/archives/2003/nov/20/disturbing-the-peace/

Maddison, Angus. *The World Economy: A Millennial Perspective*. Paris: Organisation for Economic Co-Operation and Development, 2001.

Majumdar, Robin, and Allen McLaurin, eds. *Virginia Woolf: The Critical Heritage*. London: Routledge & Kegan Paul, 1975.

Marcus, Jane. *Art and Anger: Reading Like a Woman*. Columbus: Ohio State University Press, 1988.

———. *Virginia Woolf and the Languages of Patriarchy.* Bloomington: Indiana University Press, 1987.

Marcus, Laura. *Virginia Woolf*. 2nd edn. Tavistock: Northcote House, 2004.

McWilliams-Tullberg, Rita. *Women at Cambridge: A Men's University, Though of a Mixed Type*. London: Gollancz, 1975.

Minow-Pinkney, Makiko. *Virginia Woolf and the Problem of the Subject*. Edinburgh: Edinburgh University Press, 2010.

Moi, Toril. *Sexual/Textual Politics: Feminist Literary Theory*. 2nd edn. London: Routledge, 2002.

Park, Sowon S. "Suffrage and Virginia Woolf: 'The Mass Behind the Single Voice'." *The Review of English Studies* 56, no. 223 (2005): 119–34.

Quiller-Couch, Arthur. *On the Art of Writing*. New York: G. P. Putnam's Sons, 1916.

Robbins, Rae Gallant. *The Bloomsbury Group: A Selective Bibliography*. 1st edn. Kenmore, WA: Price Guide Publishers, 1978.

Sarkar, Tapan K., Robert J. Mailloux, Arthur A. Oliner, Magdalena Salazar-Palma, and Dipak L. Sengupta. *History of Wireless*. Hoboken, NJ: Wiley-Interscience, 2006.

Schreiner, Olive. *Woman and Labour*. London: T. Fisher Unwin, 1911.

Showalter, Elaine. *A Literature of Their Own: From Charlotte Brontë to Doris Lessing*. Princeton: Princeton University Press, 1999.

Spalding, Frances. *The Bloomsbury Group*. London: National Portrait Gallery, 2005.

Walker, Alice. *In Search of Our Mothers' Gardens: Womanist Prose*. London: Phoenix, 2005.

Weininger, Otto. *Sex and Character* (London: William Heinemann, 1906).

Whitworth, Michael H. *Virginia Woolf*. Oxford: Oxford University Press, 2005.

Wollstonecraft, Mary. *A Vindication of the Rights of Woman*. Edited by Deidre Shauna Lynch. New York: W. W. Norton, 2009.

Wood, James. "A Frog's Life: *Elizabeth Costello: Eight Lessons* by J. M. Coetzee." *London Review of Books* 25, no. 20 (October 23, 2003): 15–16.

Woolf, Virginia. *A Room of One's Own* and *Three Guineas*. Edited by Anna Snaith. Oxford: Oxford University Press, 2015.

———. *Women & Fiction: The Manuscript Versions of A Room of One's Own*. Edited by S. P. Rosenbaum. Oxford: Blackwell, 1992.

———.*Women and Writing.* Edited by Michèle Barrett. London: Women's Press, 1979.

———. *A Writer's Diary*. Edited by Leonard Woolf. London: Harcourt, 1954.

Zwerdling, Alex. *Virginia Woolf and the Real World*. Berkeley: University of California Press, 1986.

THE MACAT LIBRARY
BY DISCIPLINE

The Macat Library By Discipline

AFRICANA STUDIES

Chinua Achebe's *An Image of Africa: Racism in Conrad's Heart of Darkness*
W. E. B. Du Bois's *The Souls of Black Folk*
Zora Neale Huston's *Characteristics of Negro Expression*
Martin Luther King Jr's *Why We Can't Wait*
Toni Morrison's *Playing in the Dark: Whiteness in the American Literary Imagination*

ANTHROPOLOGY

Arjun Appadurai's *Modernity at Large: Cultural Dimensions of Globalisation*
Philippe Ariès's *Centuries of Childhood*
Franz Boas's *Race, Language and Culture*
Kim Chan & Renée Mauborgne's *Blue Ocean Strategy*
Jared Diamond's *Guns, Germs & Steel: the Fate of Human Societies*
Jared Diamond's *Collapse: How Societies Choose to Fail or Survive*
E. E. Evans-Pritchard's *Witchcraft, Oracles and Magic Among the Azande*
James Ferguson's *The Anti-Politics Machine*
Clifford Geertz's *The Interpretation of Cultures*
David Graeber's *Debt: the First 5000 Years*
Karen Ho's *Liquidated: An Ethnography of Wall Street*
Geert Hofstede's *Culture's Consequences: Comparing Values, Behaviors, Institutes and Organizations across Nations*
Claude Lévi-Strauss's *Structural Anthropology*
Jay Macleod's *Ain't No Makin' It: Aspirations and Attainment in a Low-Income Neighborhood*
Saba Mahmood's *The Politics of Piety: The Islamic Revival and the Feminist Subjec*t
Marcel Mauss's *The Gift*

BUSINESS

Jean Lave & Etienne Wenger's *Situated Learning*
Theodore Levitt's *Marketing Myopia*
Burton G. Malkiel's *A Random Walk Down Wall Street*
Douglas McGregor's *The Human Side of Enterprise*
Michael Porter's *Competitive Strategy: Creating and Sustaining Superior Performance*
John Kotter's *Leading Change*
C. K. Prahalad & Gary Hamel's *The Core Competence of the Corporation*

CRIMINOLOGY

Michelle Alexander's *The New Jim Crow: Mass Incarceration in the Age of Colorblindness*
Michael R. Gottfredson & Travis Hirschi's *A General Theory of Crime*
Richard Herrnstein & Charles A. Murray's *The Bell Curve: Intelligence and Class Structure in American Life*
Elizabeth Loftus's *Eyewitness Testimony*
Jay Macleod's *Ain't No Makin' It: Aspirations and Attainment in a Low-Income Neighborhood*
Philip Zimbardo's *The Lucifer Effect*

ECONOMICS

Janet Abu-Lughod's *Before European Hegemony*
Ha-Joon Chang's *Kicking Away the Ladder*
David Brion Davis's *The Problem of Slavery in the Age of Revolution*
Milton Friedman's *The Role of Monetary Policy*
Milton Friedman's *Capitalism and Freedom*
David Graeber's *Debt: the First 5000 Years*
Friedrich Hayek's *The Road to Serfdom*
Karen Ho's *Liquidated: An Ethnography of Wall Street*

John Maynard Keynes's *The General Theory of Employment, Interest and Money*
Charles P. Kindleberger's *Manias, Panics and Crashes*
Robert Lucas's *Why Doesn't Capital Flow from Rich to Poor Countries?*
Burton G. Malkiel's *A Random Walk Down Wall Street*
Thomas Robert Malthus's *An Essay on the Principle of Population*
Karl Marx's *Capital*
Thomas Piketty's *Capital in the Twenty-First Century*
Amartya Sen's *Development as Freedom*
Adam Smith's *The Wealth of Nations*
Nassim Nicholas Taleb's *The Black Swan: The Impact of the Highly Improbable*
Amos Tversky's & Daniel Kahneman's *Judgment under Uncertainty: Heuristics and Biases*
Mahbub Ul Haq's *Reflections on Human Development*
Max Weber's *The Protestant Ethic and the Spirit of Capitalism*

FEMINISM AND GENDER STUDIES

Judith Butler's *Gender Trouble*
Simone De Beauvoir's *The Second Sex*
Michel Foucault's *History of Sexuality*
Betty Friedan's *The Feminine Mystique*
Saba Mahmood's *The Politics of Piety: The Islamic Revival and the Feminist Subject*
Joan Wallach Scott's *Gender and the Politics of History*
Mary Wollstonecraft's *A Vindication of the Rights of Woman*
Virginia Woolf's *A Room of One's Own*

GEOGRAPHY

The Brundtland Report's *Our Common Future*
Rachel Carson's *Silent Spring*
Charles Darwin's *On the Origin of Species*
James Ferguson's *The Anti-Politics Machine*
Jane Jacobs's *The Death and Life of Great American Cities*
James Lovelock's *Gaia: A New Look at Life on Earth*
Amartya Sen's *Development as Freedom*
Mathis Wackernagel & William Rees's *Our Ecological Footprint*

HISTORY

Janet Abu-Lughod's *Before European Hegemony*
Benedict Anderson's *Imagined Communities*
Bernard Bailyn's *The Ideological Origins of the American Revolution*
Hanna Batatu's *The Old Social Classes And The Revolutionary Movements Of Iraq*
Christopher Browning's *Ordinary Men: Reserve Police Batallion 101 and the Final Solution in Poland*
Edmund Burke's *Reflections on the Revolution in France*
William Cronon's *Nature's Metropolis: Chicago And The Great West*
Alfred W. Crosby's *The Columbian Exchange*
Hamid Dabashi's *Iran: A People Interrupted*
David Brion Davis's *The Problem of Slavery in the Age of Revolution*
Nathalie Zemon Davis's *The Return of Martin Guerre*
Jared Diamond's *Guns, Germs & Steel: the Fate of Human Societies*
Frank Dikotter's *Mao's Great Famine*
John W Dower's *War Without Mercy: Race And Power In The Pacific War*
W. E. B. Du Bois's *The Souls of Black Folk*
Richard J. Evans's *In Defence of History*
Lucien Febvre's *The Problem of Unbelief in the 16th Century*
Sheila Fitzpatrick's *Everyday Stalinism*

Eric Foner's *Reconstruction: America's Unfinished Revolution, 1863-1877*
Michel Foucault's *Discipline and Punish*
Michel Foucault's *History of Sexuality*
Francis Fukuyama's *The End of History and the Last Man*
John Lewis Gaddis's *We Now Know: Rethinking Cold War History*
Ernest Gellner's *Nations and Nationalism*
Eugene Genovese's *Roll, Jordan, Roll: The World the Slaves Made*
Carlo Ginzburg's *The Night Battles*
Daniel Goldhagen's *Hitler's Willing Executioners*
Jack Goldstone's *Revolution and Rebellion in the Early Modern World*
Antonio Gramsci's *The Prison Notebooks*
Alexander Hamilton, John Jay & James Madison's *The Federalist Papers*
Christopher Hill's *The World Turned Upside Down*
Carole Hillenbrand's *The Crusades: Islamic Perspectives*
Thomas Hobbes's *Leviathan*
Eric Hobsbawm's *The Age Of Revolution*
John A. Hobson's *Imperialism: A Study*
Albert Hourani's *History of the Arab Peoples*
Samuel P. Huntington's *The Clash of Civilizations and the Remaking of World Order*
C. L. R. James's *The Black Jacobins*
Tony Judt's *Postwar: A History of Europe Since 1945*
Ernst Kantorowicz's *The King's Two Bodies: A Study in Medieval Political Theology*
Paul Kennedy's *The Rise and Fall of the Great Powers*
Ian Kershaw's *The "Hitler Myth": Image and Reality in the Third Reich*
John Maynard Keynes's *The General Theory of Employment, Interest and Money*
Charles P. Kindleberger's *Manias, Panics and Crashes*
Martin Luther King Jr's *Why We Can't Wait*
Henry Kissinger's *World Order: Reflections on the Character of Nations and the Course of History*
Thomas Kuhn's *The Structure of Scientific Revolutions*
Georges Lefebvre's *The Coming of the French Revolution*
John Locke's *Two Treatises of Government*
Niccolò Machiavelli's *The Prince*
Thomas Robert Malthus's *An Essay on the Principle of Population*
Mahmood Mamdani's *Citizen and Subject: Contemporary Africa And The Legacy Of Late Colonialism*
Karl Marx's *Capital*
Stanley Milgram's *Obedience to Authority*
John Stuart Mill's *On Liberty*
Thomas Paine's *Common Sense*
Thomas Paine's *Rights of Man*
Geoffrey Parker's *Global Crisis: War, Climate Change and Catastrophe in the Seventeenth Century*
Jonathan Riley-Smith's *The First Crusade and the Idea of Crusading*
Jean-Jacques Rousseau's *The Social Contract*
Joan Wallach Scott's *Gender and the Politics of History*
Theda Skocpol's *States and Social Revolutions*
Adam Smith's *The Wealth of Nations*
Timothy Snyder's *Bloodlands: Europe Between Hitler and Stalin*
Sun Tzu's *The Art of War*
Keith Thomas's *Religion and the Decline of Magic*
Thucydides's *The History of the Peloponnesian War*
Frederick Jackson Turner's *The Significance of the Frontier in American History*
Odd Arne Westad's *The Global Cold War: Third World Interventions And The Making Of Our Times*

LITERATURE

Chinua Achebe's *An Image of Africa: Racism in Conrad's Heart of Darkness*
Roland Barthes's *Mythologies*
Homi K. Bhabha's *The Location of Culture*
Judith Butler's *Gender Trouble*
Simone De Beauvoir's *The Second Sex*
Ferdinand De Saussure's *Course in General Linguistics*
T. S. Eliot's *The Sacred Wood: Essays on Poetry and Criticism*
Zora Neale Huston's *Characteristics of Negro Expression*
Toni Morrison's *Playing in the Dark: Whiteness in the American Literary Imagination*
Edward Said's *Orientalism*
Gayatri Chakravorty Spivak's *Can the Subaltern Speak?*
Mary Wollstonecraft's *A Vindication of the Rights of Women*
Virginia Woolf's *A Room of One's Own*

PHILOSOPHY

Elizabeth Anscombe's *Modern Moral Philosophy*
Hannah Arendt's *The Human Condition*
Aristotle's *Metaphysics*
Aristotle's *Nicomachean Ethics*
Edmund Gettier's *Is Justified True Belief Knowledge?*
Georg Wilhelm Friedrich Hegel's *Phenomenology of Spirit*
David Hume's *Dialogues Concerning Natural Religion*
David Hume's *The Enquiry for Human Understanding*
Immanuel Kant's *Religion within the Boundaries of Mere Reason*
Immanuel Kant's *Critique of Pure Reason*
Søren Kierkegaard's *The Sickness Unto Death*
Søren Kierkegaard's *Fear and Trembling*
C. S. Lewis's *The Abolition of Man*
Alasdair MacIntyre's *After Virtue*
Marcus Aurelius's *Meditations*
Friedrich Nietzsche's *On the Genealogy of Morality*
Friedrich Nietzsche's *Beyond Good and Evil*
Plato's *Republic*
Plato's *Symposium*
Jean-Jacques Rousseau's *The Social Contract*
Gilbert Ryle's *The Concept of Mind*
Baruch Spinoza's *Ethics*
Sun Tzu's *The Art of War*
Ludwig Wittgenstein's *Philosophical Investigations*

POLITICS

Benedict Anderson's *Imagined Communities*
Aristotle's *Politics*
Bernard Bailyn's *The Ideological Origins of the American Revolution*
Edmund Burke's *Reflections on the Revolution in France*
John C. Calhoun's *A Disquisition on Government*
Ha-Joon Chang's *Kicking Away the Ladder*
Hamid Dabashi's *Iran: A People Interrupted*
Hamid Dabashi's *Theology of Discontent: The Ideological Foundation of the Islamic Revolution in Iran*
Robert Dahl's *Democracy and its Critics*
Robert Dahl's *Who Governs?*
David Brion Davis's *The Problem of Slavery in the Age of Revolution*

The Macat Library By Discipline

Alexis De Tocqueville's *Democracy in America*
James Ferguson's *The Anti-Politics Machine*
Frank Dikotter's *Mao's Great Famine*
Sheila Fitzpatrick's *Everyday Stalinism*
Eric Foner's *Reconstruction: America's Unfinished Revolution, 1863-1877*
Milton Friedman's *Capitalism and Freedom*
Francis Fukuyama's *The End of History and the Last Man*
John Lewis Gaddis's *We Now Know: Rethinking Cold War History*
Ernest Gellner's *Nations and Nationalism*
David Graeber's *Debt: the First 5000 Years*
Antonio Gramsci's *The Prison Notebooks*
Alexander Hamilton, John Jay & James Madison's *The Federalist Papers*
Friedrich Hayek's *The Road to Serfdom*
Christopher Hill's *The World Turned Upside Down*
Thomas Hobbes's *Leviathan*
John A. Hobson's *Imperialism: A Study*
Samuel P. Huntington's *The Clash of Civilizations and the Remaking of World Order*
Tony Judt's *Postwar: A History of Europe Since 1945*
David C. Kang's *China Rising: Peace, Power and Order in East Asia*
Paul Kennedy's *The Rise and Fall of Great Powers*
Robert Keohane's *After Hegemony*
Martin Luther King Jr.'s *Why We Can't Wait*
Henry Kissinger's *World Order: Reflections on the Character of Nations and the Course of History*
John Locke's *Two Treatises of Government*
Niccolò Machiavelli's *The Prince*
Thomas Robert Malthus's *An Essay on the Principle of Population*
Mahmood Mamdani's *Citizen and Subject: Contemporary Africa And The Legacy Of Late Colonialism*
Karl Marx's *Capital*
John Stuart Mill's *On Liberty*
John Stuart Mill's *Utilitarianism*
Hans Morgenthau's *Politics Among Nations*
Thomas Paine's *Common Sense*
Thomas Paine's *Rights of Man*
Thomas Piketty's *Capital in the Twenty-First Century*
Robert D. Putman's *Bowling Alone*
John Rawls's *Theory of Justice*
Jean-Jacques Rousseau's *The Social Contract*
Theda Skocpol's *States and Social Revolutions*
Adam Smith's *The Wealth of Nations*
Sun Tzu's *The Art of War*
Henry David Thoreau's *Civil Disobedience*
Thucydides's *The History of the Peloponnesian War*
Kenneth Waltz's *Theory of International Politics*
Max Weber's *Politics as a Vocation*
Odd Arne Westad's *The Global Cold War: Third World Interventions And The Making Of Our Times*

POSTCOLONIAL STUDIES

Roland Barthes's *Mythologies*
Frantz Fanon's *Black Skin, White Masks*
Homi K. Bhabha's *The Location of Culture*
Gustavo Gutiérrez's *A Theology of Liberation*
Edward Said's *Orientalism*
Gayatri Chakravorty Spivak's *Can the Subaltern Speak?*

PSYCHOLOGY

Gordon Allport's *The Nature of Prejudice*
Alan Baddeley & Graham Hitch's *Aggression: A Social Learning Analysis*
Albert Bandura's *Aggression: A Social Learning Analysis*
Leon Festinger's *A Theory of Cognitive Dissonance*
Sigmund Freud's *The Interpretation of Dreams*
Betty Friedan's *The Feminine Mystique*
Michael R. Gottfredson & Travis Hirschi's *A General Theory of Crime*
Eric Hoffer's *The True Believer: Thoughts on the Nature of Mass Movements*
William James's *Principles of Psychology*
Elizabeth Loftus's *Eyewitness Testimony*
A. H. Maslow's *A Theory of Human Motivation*
Stanley Milgram's *Obedience to Authority*
Steven Pinker's *The Better Angels of Our Nature*
Oliver Sacks's *The Man Who Mistook His Wife For a Hat*
Richard Thaler & Cass Sunstein's *Nudge: Improving Decisions About Health, Wealth and Happiness*
Amos Tversky's *Judgment under Uncertainty: Heuristics and Biases*
Philip Zimbardo's *The Lucifer Effect*

SCIENCE

Rachel Carson's *Silent Spring*
William Cronon's *Nature's Metropolis: Chicago And The Great West*
Alfred W. Crosby's *The Columbian Exchange*
Charles Darwin's *On the Origin of Species*
Richard Dawkin's *The Selfish Gene*
Thomas Kuhn's *The Structure of Scientific Revolutions*
Geoffrey Parker's *Global Crisis: War, Climate Change and Catastrophe in the Seventeenth Century*
Mathis Wackernagel & William Rees's *Our Ecological Footprint*

SOCIOLOGY

Michelle Alexander's *The New Jim Crow: Mass Incarceration in the Age of Colorblindness*
Gordon Allport's *The Nature of Prejudice*
Albert Bandura's *Aggression: A Social Learning Analysis*
Hanna Batatu's *The Old Social Classes And The Revolutionary Movements Of Iraq*
Ha-Joon Chang's *Kicking Away the Ladder*
W. E. B. Du Bois's *The Souls of Black Folk*
Émile Durkheim's *On Suicide*
Frantz Fanon's *Black Skin, White Masks*
Frantz Fanon's *The Wretched of the Earth*
Eric Foner's *Reconstruction: America's Unfinished Revolution, 1863-1877*
Eugene Genovese's *Roll, Jordan, Roll: The World the Slaves Made*
Jack Goldstone's *Revolution and Rebellion in the Early Modern World*
Antonio Gramsci's *The Prison Notebooks*
Richard Herrnstein & Charles A Murray's *The Bell Curve: Intelligence and Class Structure in American Life*
Eric Hoffer's *The True Believer: Thoughts on the Nature of Mass Movements*
Jane Jacobs's *The Death and Life of Great American Cities*
Robert Lucas's *Why Doesn't Capital Flow from Rich to Poor Countries?*
Jay Macleod's *Ain't No Makin' It: Aspirations and Attainment in a Low Income Neighborhood*
Elaine May's *Homeward Bound: American Families in the Cold War Era*
Douglas McGregor's *The Human Side of Enterprise*
C. Wright Mills's *The Sociological Imagination*

Thomas Piketty's *Capital in the Twenty-First Century*
Robert D. Putman's *Bowling Alone*
David Riesman's *The Lonely Crowd: A Study of the Changing American Character*
Edward Said's *Orientalism*
Joan Wallach Scott's *Gender and the Politics of History*
Theda Skocpol's *States and Social Revolutions*
Max Weber's *The Protestant Ethic and the Spirit of Capitalism*

THEOLOGY

Augustine's *Confessions*
Benedict's *Rule of St Benedict*
Gustavo Gutiérrez's *A Theology of Liberation*
Carole Hillenbrand's *The Crusades: Islamic Perspectives*
David Hume's *Dialogues Concerning Natural Religion*
Immanuel Kant's *Religion within the Boundaries of Mere Reason*
Ernst Kantorowicz's *The King's Two Bodies: A Study in Medieval Political Theology*
Søren Kierkegaard's *The Sickness Unto Death*
C. S. Lewis's *The Abolition of Man*
Saba Mahmood's *The Politics of Piety: The Islamic Revival and the Feminist Subject*
Baruch Spinoza's *Ethics*
Keith Thomas's *Religion and the Decline of Magic*

COMING SOON

Chris Argyris's *The Individual and the Organisation*
Seyla Benhabib's *The Rights of Others*
Walter Benjamin's *The Work Of Art in the Age of Mechanical Reproduction*
John Berger's *Ways of Seeing*
Pierre Bourdieu's *Outline of a Theory of Practice*
Mary Douglas's *Purity and Danger*
Roland Dworkin's *Taking Rights Seriously*
James G. March's *Exploration and Exploitation in Organisational Learning*
Ikujiro Nonaka's *A Dynamic Theory of Organizational Knowledge Creation*
Griselda Pollock's *Vision and Difference*
Amartya Sen's *Inequality Re-Examined*
Susan Sontag's *On Photography*
Yasser Tabbaa's *The Transformation of Islamic Art*
Ludwig von Mises's *Theory of Money and Credit*

Printed in the United States
by Baker & Taylor Publisher Services